The Lovers' Guide to Homemade Video

T0088055

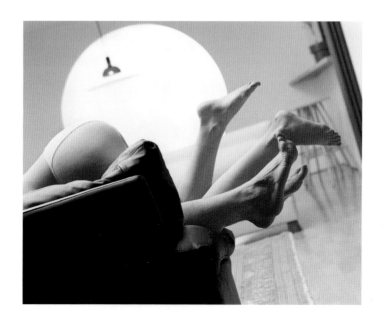

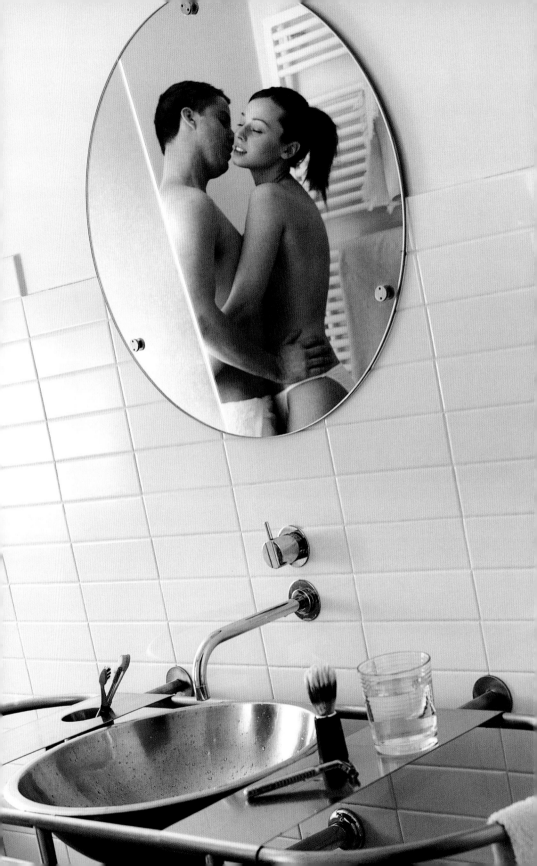

The Lovers' Guide to Homemade Video

SERENA VALLÉS

with Carlos Martínez

Translated by Rev. Kevin Strickland Moran

Tips and Techniques for Making Your Own Erotic Movies

Skyhorse Publishing

Original title: CÓMO RODAR UN VÍDEO ERÓTICO CASERO
© 2003 Serena Vallés
© 2004 Editorial Océano, S.L. (Barcelona, Spain)
Illustrations: M&G Studios, Ramon Pomarol, Océano Ambar and P&M archives unless otherwise noted
English translation © 2014 by Skyhorse Publishing

Skyhorse Publishing books may be purchased in bulk at special discounts for sales promotion, corporate gifts, fund-raising, or educational purposes. Special editions can also be created to specifications. For details, contact the Special Sales Department, Skyhorse Publishing, 307 West 36th Street, 11th Floor, New York, NY 10018 or info@ skyhorsepublishing.com.

Skyhorse® and Skyhorse Publishing® are registered trademarks of Skyhorse Publishing, Inc.®, a Delaware corporation.

Visit our website at www.skyhorsepublishing.com.

10 9 8 7 6 5 4 3 2 1

Library of Congress Cataloging-in-Publication Data is available on file.

Cover design by Rain Saukas
Cover photo credit courtesy of Océano Ambar

ISBN: 978-1-62914-475-7
Ebook ISBN 978-1-62914-997-4
Printed in Hong Kong

Contents

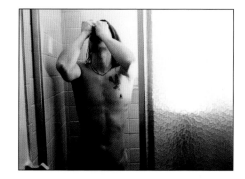

Testimonials

A male perspective: Carlos

I met Bertha at a party two years before my marriage ended in separation, but the relationship was over long before that. I didn't want to go back to the same boring, predictable routine of working life. Work, hobbies, and leisure activities weren't enough. That's why they said I was lucky. Because from the very moment we saw each other, we have not been able to stop talking, stop traveling, or do anything apart.

We both have a deep passion for art. At first she said she was Cuban, but soon admitted that she spent a few years in Tenerife, in paradise. Bertha is an adorable creature, a never-ending treasure. Her inner life is as rich as her private life is wild. It is part spiritual and part high-voltage erotic. And she is much younger, although you would not know it from talking to her.

Sometimes we go out with friends, and sometimes we enjoy our personal space. But what we prefer and rely on is to be in each other's company and the things that we get up to when we are there. Until now we have photographed (on the new cell phone she gave me and on the digital camera I gave her) or recorded vacation and family films; this is why I was surprised by her idea, born on a trip, a vacation, out of recording a very intimate moment on film...

I always imagined that this, even though it started as a game, could become something much more than that. I have noticed that it has turned into something that can tell you a lot about yourself, tell us a lot about ourselves as a couple, to the point that we are turning it into a powerful tool for self-discovery, once we have passed many of our inhibitions—and some limitations—related to the feeling of embarrassment or certain feelings of shame. Since then, modesty has had a very different meaning for us.

We have to warn you: even though any adult is able to experience this lifestyle, not everyone should. Keep in mind that there are many people who like it and many who don't, and that makes sense. It is important to accept and understand this; moreover, not everyone is ready, or one of the two of you might not agree (and in this case you should stop), or it is not possible for whatever reason. We suggest that you do not force these things.

Furthermore, at the time of writing this book, we were unsure as to how to write it. More sexy or more sentimental. We chose the former.

Often you should not carry through with a home video of any kind, even less so if it is erotic or remotely sexual (we suggest you read the warnings at the end of this section carefully before anything else). It is very important, before embarking on this adventure, to take an approach of maximum discretion and mutual trust. And sometimes, in the event of a traumatic breakup, have a document signed by both people to clarify certain things.

In any event, some of our family members know about this fun (you can imagine the initial surprise once we decided to talk about it). Even though the first questions are always the same or very similar ("Are you serious?"), the most reassuring thing to everyone

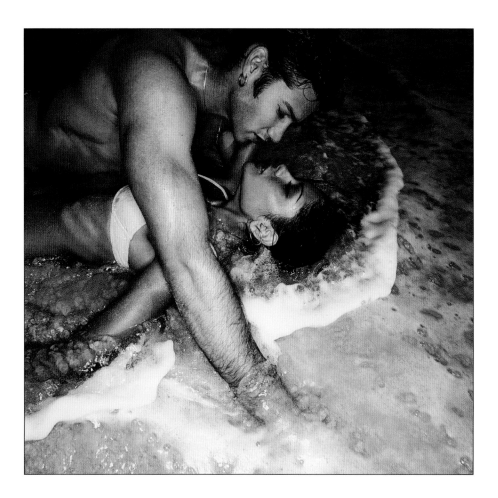

is seeing our radiant (and authentic) happiness. More than a memory, these videos are a revelation for us, a kind of travel documentary for our inner selves. Needless to say we do not want anything to do with swingers and their private videos (and there are many of them). She doesn't like that and I don't either. From my minimal experience in the time of hippies, I remember that the girl I dated had a hard time separating real, sincere, and committed love from sexual practices, even though, of course, they are very closely related. But that would

be, maybe, one of the few emotional issues about which men have something to say. So our case may not be typical, but we like it that way. What started as a hobby and a little bit of fun has become an irresistible form of learning.

And we don't have a reason to change. As I already mentioned, we know other couples who share their recordings, but this is not the case for us; it does not interest us. We only want to know ourselves better. We even know of people who ended up dedicating themselves to making films that were more or less porn.

Also people who, with the use of the Internet, had put a camera in their bedroom for commercial use targeted at voyeurs (it still amazes me, the voyeur that we all carry inside. Think if not about the success of TV shows with hidden cameras).

Instead, it is worthwhile to mention that our intimate lives have transformed into something absolutely magical and where before we felt a few tickles, now we can feel that tremor that runs through your body, from neck to toe, and that seems to invite us to return to the start and connect with the unknown… So we recommend it. Getting started is very easy, so good luck!

Elisa's experience

Before I met Juan, I had no awareness of my body. I knew that I had two legs because I used them to walk or two arms because they carried my groceries when I went to the supermarket … but little else. Since I was widowed five years ago, I have forgotten my body and my sexuality, little by little. Fleeing mirrors like a vampire, I showered quickly without paying attention to my young body. My body, aware of my neglect, was slowly fading. Then I met Juan, a six-foot blond angel who made me feel alive again. When I ran into him on the stairs and he told me that he had moved to the apartment next door three months ago, I didn't believe what he was saying. How could I have been so blind that I did not see him until then? At first our meetings were limited to the occasional visit to ask for "a little salt" or "some flour." One day, Juan came to the door with this excuse and surprised me

with an apron and a face full of flour; I explained to him that I was making a cake and he asked me to let him see how it was done. I don't remember how it happened but we ended up on the kitchen table covered in cream and flour, making love. After that meeting, we started to visit each other frequently asking for things like a "passionate kiss," or even "a fiery romp." We worked well sexually, we understood each other perfectly, but I continued to have my hangups and complexes. He would not stop repeating how much he loved my full breasts or round ass, but I still didn't want to look at myself. When we did it, I concentrated on his handsome body and I forgot about mine; I even preferred to do it in the dark or with the lights dimmed. One day he asked me if we could do it in front of an enormous mirror—what a surprise! At first I only looked at his excited face, his tense body while he forced me against the wall, his arms tensed, his penis erect. But then I noticed my face flushed with excitement, my body curled and coupled with his, my round, free breasts hitting his chest … and I felt strong and beautiful. That image hit me like nothing before, and he noticed. That is why I was not surprised when a week later he appeared with a camera under his arm. He also had the manuscript of this book you now hold in your hands. He explained to me that his friend Serena was writing a book on how to shoot erotic videos and she had asked him to read it and give her his opinion—Juan is an editor. Full of curiosity, we began to read about Serena's experiences. I loved the book; to me it was steamy and, at the same time, complicated and erotic. I understood that it was a creative way to enjoy sex

but definitely was not for me. Just as I guessed, Juan asked if we could film ourselves. I told him that it was too much, that I was not prepared to see myself in that situation, that I would die of shame. Then he reminded me how much I enjoyed watching the reflection of our lovemaking in the mirror and promised me that it would be a simple video. We started filming passionate kisses between laughter and with our hands covering the shot. Later we filmed movement in the sheets where you couldn't see more than our legs and arms playfully sticking out the sides. Later, rather than arouse us, watching what we filmed made us fall over in fits of laughter. Little by little, and following the advice of Serena—this manuscript became my bedside reading—I was overcoming my modesty and letting go a little every day. One day, while Juan held the camera and I was slowly and suggestively stripping, I felt sure of myself, proud of my naked body, and ready to immortalize all of the sensuality I was able to give off. Juan shook at the sight and entered the scene enough to be able to slip my panties down my legs. That day we made love three times: once on camera and two more times after watching what we filmed.

After this experience I discovered that shooting erotic videos turned into an excellent therapy for me to get to know and love my body. I am over the shame and the modesty, and my sex life has reached unexpected levels.

Thanks to Juan—and to Serena—I've learned that sex is like a cake that you must attend to and to which you must vary the ingredients so that it intoxicates and surprises you with its mix of flavors. The only requirement is to consider your tastes, to be in agreement

Warnings

* No one involved in the creation of this book supports illegal activities. The distribution of erotic images is illegal in certain countries.
* Ensure that your personal or private images cannot be used without your consent, for your protection, to prevent any possible misuse.
* We also suggest you anticipate the final destination of these images in the event of the relationship ending.
* Finally, if necessary, it is both easy and affordable now to save a copy of your images.

The photographs throughout this book have been taken by professional models, some following our instructions. The rest have been selected from an editorial archive.

with your partner, and to allow yourself to be carried away by the thrill of shared pleasure. Each video that we recorded turned into an exciting and endearing memory of our most intimate moments. The best part is that we can enjoy them whenever we want. I imagine watching these erotic movies, hand in hand, when we are old and tender, and unable to avoid shaking from excitement.

Introduction

I never imagined that I would be filming "naughty" videos with my partner. I'm not shy about sex, but I was a little hesitant to see myself in certain situations. I can't say that he convinced me; he didn't try. It came naturally, a complicated game between two people and, all of a sudden, I saw myself filming him while he slept, his mouth open, his naked brown body against white sheets, so I could gather some secret footage with which to surprise him.

I filmed a bit. While I filmed him I had to hold back my laughter. I felt like a thief, even though I knew that he would not be mad; in fact, he would love it, because he was the one who brought the camera into the house and filmed me while I gave an absurd striptease. Between laughs, he set the camera on the furniture to join me in my crazy dance and the two of us went at it. That was our first production together: maybe it was not very sexy or very careful, but the result was very fun.

That is why when he suggested we make another film, this time with a script, I decided to go ahead and launch myself into it. I "directed" my first mildly erotic film, very subtle and without great technical displays: I had no idea about framing, shots, or composition.

I got the shots that I needed in a few tries and I even put the camera on a tripod and filmed my hands softly caressing his body. I hid the camera and filmed the two of us together. I pieced it together as well as I could, using only the smoothest shots of us, but it remained somewhere between tender and sensual, most of all because of the song that played in the background: "More Than Words" by Extreme.

Filming videos together has further strengthened our relationship. We both feel that we have given ourselves completely to each other. We are completely confident in each other—which does not say that we don't respect our space, our independence, and our identity (the opposite, really).

I know that he would never use anything to hurt me and our adventures wouldn't leave our room. We started small, but we have done more and more, and now we put a lot into our productions. Like this book, we have traveled the road of spontaneous (and madcap) erotic films to carefully planned porn.

The best part of the movie? Perhaps when you see us going at it together. It is terribly exciting to see ourselves doing it, like professionals or like amateurs, either way, and to also be a devoted audience carried away by passion.

Objectives

This book does not claim to make you porn stars, but simply, to let you access new possibilities in your sexuality and allow you to further enjoy it, sexually and creatively.

Trust is the key to start. It is important that you both are sure that the game is just for you and that no one else will see your movies, and that you will not be concerned with some music videos that contain a hint of the erotic, which I will address (which you can even make with your friends or maybe you both want to share your creations with another couple interested in homemade erotic videos).

In most cases it will simply be a reminder of your passion, of your best moments, or that day that you were especially seductive and you both prefer to keep strictly private. No matter what, you both have limits, and it is not worth pressuring each other past them, however you can ask. Accept the decisions that you both have made. Learn about yourselves, your boundaries, and the boundaries of your partner.

You can tell a lot about a person by the way they use a camera: What type of angles do they prefer? Do they like wide shots that do not show detail or close-ups? What part of the body do they like to focus on?

I do not want to direct you. I only bring suggestions that can serve as a starting point. Your own creativity will help you to make your own stories, images, situations, and scripts, as soft-core or as hard-core as you would like.

Personally, although I have not taken this step, I do not see an issue sharing films or burning videos with people who create their own movies. I have to admit that sometimes, when I'm feeling naughty, I want to carry our filthiest videos in my purse when we go to see married friends. And when it eventually comes time to film our wedding video . . .

Our films . . . are much better!

The tools of the language of film

In this book I don't aim to make you an expert filmmaker and won't ask too much of those who want to simply flirt with the seventh art to make amateur films of the suggestive, erotic, or even risqué nature. Nevertheless, it is necessary to know a few rudimentary cinematographic terms to best communicate our films and the ideas we have in our heads before they are put into images.

A film, whatever the genre, tells a story. In these videos we can tell a story via a plot with a beginning, a middle, and an end, or simply narrate the encounter of two people, in our case with an erotic air.

Any film requires some planning, even if the goal is only to show how desirable our partner is without anything else

happening. What shots will best show our partner? How do we want to highlight her? How are you going to interact with the environment? Will you carry something with you? Will you interact with another person?

Do we want to show thoughts or feelings and therefore need to include a close-up of a face? What significance do different action shots carry or the development of the story? What rhythm will the story have? What are the different shots going to contribute to the rhythm?

It's not as complicated as it seems. You only need to know the elements that enable cinematic storytelling and combine them according to your taste. This personal taste of the director is called style. No matter what, every director, even amateur, has to make sure that the language is not so personal that only they understand it.

Equipment

It is not about buying the most expensive equipment as much as it is about how you use it. In any event, it is worth investing in a camera to make erotic videos because your sex life will be reinvigorated. Furthermore, there are many landscapes to film, trips to take, children to watch grow, and opportunities to film. You can also try to capitalize on filming weddings, communions, baptisms, birthdays. If you make a good, original, and personal production, success will follow.

Digital cameras are flooding the market. They are improving and incorporating many new features. Tip: It is better that the zoom is optical because the quality of the image is better and does not lose focus in action.

Mini DV's have a higher-quality image and are very small and manageable. Mini DV systems allow two audio tracks (stereo) to be recorded in high quality (CD or DAT) at 48 khz and 16 bits. They also allow four tracks but at a lower quality (32 khz/12 bits).

Remember that the more compact, the more expensive, and you can get an older camera that is of a much higher quality at the same price. I understand that some people do not like their cameras to be too small because they become hard to use.

Another advantage of digital cameras is that they allow editing directly on the computer so that the production can be more thought-out and personal.

What is the best camera? Most cameras are not different enough for that to matter.

Think about the effects that you might use and ask about them at the store. Perhaps you would like to shoot in sepia

Camera-ready!

Invest in a camera that fits your needs and enhances your sex life.

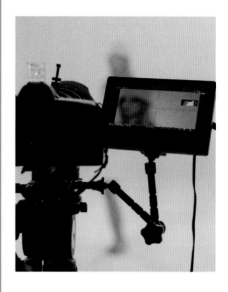

like an old movie or in black and white to make the images more dramatic. Ask— these things are available on most cameras.

If you have an analog camera, you do not need to invest in a digital one if you are not convinced that it would be right for you. You can also do great things with an analog camera. If you really like the idea of making movies, erotic or not, you can always buy better equipment.

Thinkstock

When you buy the camera, make sure that it can shoot in low light. Remember that you will have much less light than a film studio would. If you do not have money for all of the gadgets that you need, you can also rent them.

Techniques

Shots, scenes, and sequences

Shots are filmed from a specific distance and angle where you put the camera until it stops. They are arranged in scenes and sequences and are the basic unit of meaning. A shot is the same as a take.

Sequences are formed from different shots, which can be very different from each other but are organized by a theme. A single car chase sequence, for instance, will be made up of many different shots.

Shots give information on the environment, characters, and their feelings. Shots have to be arranged in a logical order. That is to say, they show the relationship of the characters in a certain setting or with other characters (wider shots), then it might move in to a closer shot to capture the character's thoughts and feelings.

In these videos, this could be an expression of pleasure on their face. For example, I love it when he looks at me with his brilliant dark and (heavy) eyes and when he smiles while he is on top of me (or underneath; he smiles at me in every position). They are special faces that I like to have recordings of so that I can see them.

Of course, the closest shots can show the whole range of emotions: doubt, tenderness, confidence, tranquility, anxiety, arousal, and they can be used at any point in the film. My boyfriend and I have found that there were faces that we did not even know that we made, and I'm not only referring to faces of pleasure.

It's not as much about going crazy over one particular shot as it is about telling a story. Each shot has a role within the sequence and gives new information to the audience.

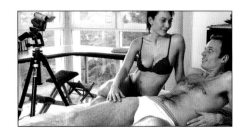

The scene

The next unit is called the scene. In it the shots are organized to form a unit with more significance. Each shot coordinates with the ones before and those after. The scene is a set of shots bound by the same setting, some of the same characters, and the same time; for example, a conversation between two or three people.

A group of scenes is called a **sequence**. A sequence is about the equivalent of the chapter of a book, and experts define it as a unit of action and organic unity.

It is like a short film within the film and though it might make sense by itself, it can be said that its meaning is completed by the other sequences, which can add more information or even show how much of a previously viewed sequence is

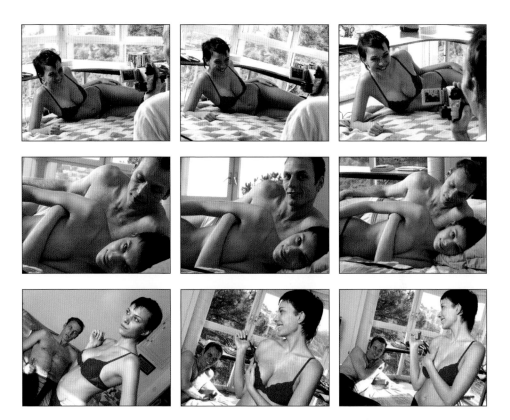

actually true. To explain, a scene can be the surprising moment in *Basic Instinct* where Sharon Stone uncrosses her legs, and the full interrogation is a sequence.

The shots, scenes, and sequences are linked together in a movie in acts, in a form that tells a story. A film structure consists of ¼ presentation, ¾ conflict, ¼ climax and resolution.

That is to say, the minor significant units combine with greater characters until they form a whole: a film.

The frames

The things that are left out of the camera's view are as important as what you decide you are going to see.

As people have discovered little by little since the early days of film, to play with the camera, while keeping the camera fixed, allows you to:

1. Leave certain elements of the action out of frame. For example, the rising actions of a striptease can be followed through the faces of the specta-tors. One of our most fun videos, at least for us (we tend not to torture guests with our videos), is very simple with my very rhythmic striptease where, as we were

putting it together, we interspersed Juan making very funny faces, including him upside down on the chair, sticking out his tongue, and cross-eyed. If the intention is to do something more "serious," insert images of an obelisk (erection) or fireworks (…).

2. Show a significant detail that turns into a symbol. For example, a painted eye looking perversely gives the impression of the evil of the protagonist, or a tongue suggestively sliding out of a mouth promising delicious futures.

3. Vary the point of view. The camera can take the perspective of one of the characters instead of always showing what the spectator would see. One can also play with the feelings of the protagonist and give him or her knowledge of the spectator. For example, a tilted angle can indicate unease.

4. Play with the depth of field to achieve spectacular effects such as a menacing character advancing toward the camera until their face is in extreme close-up.

5. Offer perspectives that are rarely seen in life. Don't stick with the obvious. In our case, use imaginative frames that convey sensation and, incidentally, optically lengthen the silhouettes.

6. Play with the composition. You can film an expression of pleasure on one's face while only giving a small profile of the other giving them a kiss.

Types of shots

According to distance

Long shot

Spans the entire set. This term usually applies to exteriors. It is usually presented at the start of a sequence or the beginning of the film. It is a very broad view predominated by landscape, the sky, the sea, or property. Its purpose is to physically locate the action.

Ensemble shot

Covers a good part of the scenery and various characters, almost always an interior shot. It focuses on what surrounds the character and the action taking place on the stage. You can use it as a transition to a close-up of a character. First, information is given on the relationship between the person and their surroundings and then, with a closer shot, information is given on the individual.

If you are filming a scene that is entirely sexual, it isn't appropriate for the protagonists to be in the very center of the scene; it is better to find a more attractive way to frame them.

Full shot

Comprised of the full body of one or a few characters. It stresses the human action over emotion. Overall, its use is informative or descriptive.

¾ Shot or "American" shot

Spans the body of the person from the face to the knees and allows you to capture the impact of the situation on them. It offers more information about the character than the full shot does, specifically about their body language.

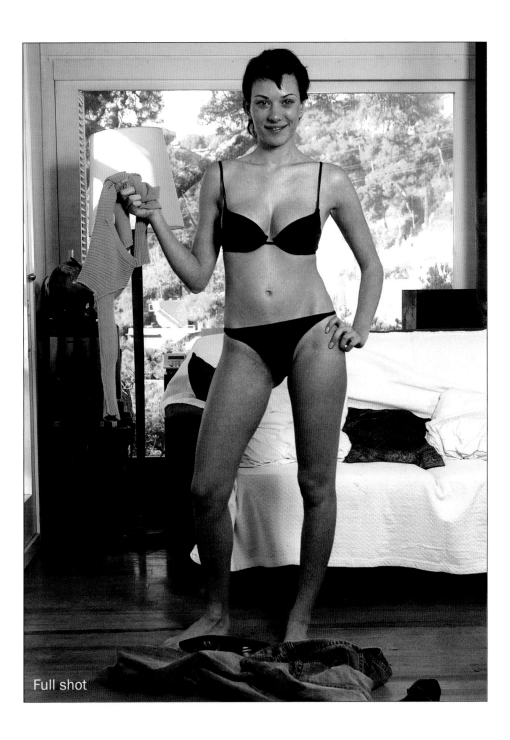

Full shot

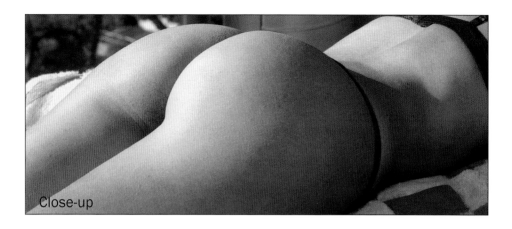
Close-up

Medium shot

Extends from the waist and the chest to the face. It is the shot for dialogue scenes. It allows the viewer to see the emotions of the character. The setting begins to lose identity.

Close-up

Shows the face of the character and little else, from the hair to the shoulders. It captures their expression and their emotions. Its uses are emotive, dramatic, and psychological. Glances and gestures gain more importance, but it allows the character very little movement, making it easy for them to exit the frame. The close-up can also frame only the face.

Extreme close-up

It only captures details such as the mouth, the eyes, or a hand. It gives no information from the environment.

Detailed shot

It is also a very close shot, but shows objects and small actions.

According to angle and height

Frontal shot

It is one-on-one between the camera and the character. It corresponds to the vision of a person of average height.

Tilted Shot

Your goal is to communicate the state of mind of a character in crisis.

High-angle shot

Taken from above, the intention is to minimize a character and highlight their weakness, submission, solitude, aban-donment, or subordination. It is a good angle, perhaps, to show a concubine.

Low-angle shot

Shot taken from below to emphasize the power of the character. It allows some-one to seem taller than they really are or make them seem more fearsome, strong, or intimidating. It also serves to lengthen legs (and call attention to them).

Camera movement

According to the movement of the camera, shots can give the feeling that the story is open to surprises. We have these four:

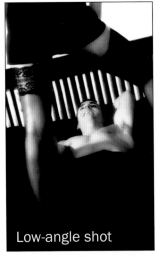

Low-angle shot

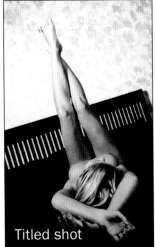

Titled shot

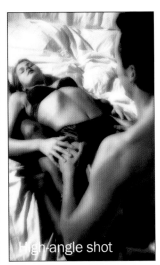

High-angle shot

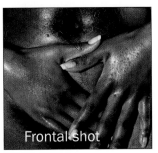

Frontal shot

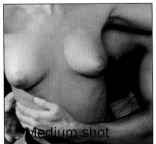

Medium shot

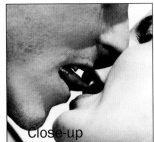

Close-up

Panoramic

Movements of the camera on its own axis. They can be horizontal or vertical, and fast or slow. Its function can be to show various elements, or call attention to a specific element above, below, or to the side of the point of view of the audience.

Tracking shot

Camera movement along a space. It is used to give the shot a more dynamic feel or to follow the movement of a character or element of the scene. It engages us in the action of the characters.

Zoom

Optical movement forward or backward. Used to isolate details or analyze an aspect of the scene or character without losing the general location.

Dolly

The movement forward or backward that a camera makes. It is a *Dolly In* if it moves forward and a *Dolly Out* if it moves backward. In Spain the term *tracking* is used to designate this movement.

Passage of time in film

An action can be produced with respect to its actual duration, without any cutting or transition, as it would happen in reality, but the norm in cinema is to change the passage of time.

The story may develop a linear, intermittent, or inverted form. It is linear when the story progresses forward, intermittent if parallel sequences are interspersed with one another, and reversed if it jumps backward or if the story is told from front to back.

In film, time shortens, lengthens, or adopts a new order through flashback (a narrative break to insert an action that has already occurred in the past), by including images from the future or through ellipses.

Films can also advance by means of *jump cuts*, which are apparent changes in position, place, or occupation of people, suggesting passage of time. For example, if a man knocks on the door and it cuts to a shot of him comfortably settled on the couch with his jacket off and his tie loosened, the audience perceives that time has passed.

The action chain is a form of making smooth transitions between shots by cutting during the action. For example, a medium shot of a person drinking cuts right when the glass is lifted from the table and follows with a close-up of the glass at the mouth. Movement between the two shots must be consistent and the montage points must be synchronized.

Slower or faster

Time can also be modified mechanically through slow motion, acceleration, and reverse, which inverts the direction in which everything moves.

Slow motion is a way to slow down real time. It can be used to create more poetic images or to see details or actions that would have been missed at normal speed. Sometimes we mix them into the middle of the film in a series of shots taken at different angles showing us "hard at work." The result was very stunning because there was so much variety, it looked so dynamic throughout the different positions, and the slowed action allowed us to see many of the details that usually go unnoticed.

You can also extend actual time by repeating shots. The interspersed repetition of two or three of the same shots in a sequence creates tension and anticipation.

Acceleration condenses actual time and is an effective comic relief. Nevertheless, the most common way to shorten time is by leaving things out, because if we show everything that really happened, the audience would be bored.

Pacing

The pacing of the film is what makes it interesting and ensures that we don't lose attention. Pacing is created with the succession of images, shots, and sequences. Shorter shots create a faster pace and longer shots a much slower pace.

A series of long shots evokes peace and quiet, while a series of close-ups creates dramatic tension. Either way, do not overuse either of the two procedures. It is best to change the pacing to suit the action and to avoid becoming monotonous by breaking the uniformity.

Different types of montage

Alternating Action

Alternates between two sequences as the film develops and causes the action to evolve. For example, you could intersperse shots of a man who walks through the street with a bouquet of flowers and the woman arranging them. The audience will realize that they are dating.

Continuous action

Cinematic narration continues without interruption or jumping back and forth.

Parallel action

A form of montage that alternates between what is happening in two or more different scenes that add information to and complement one another. The objective of parallel action is to multiply the tension. Normally the two actions are related to each other and converge on the same point.

Split shots

Its role is to intensify the relationship between characters. If you shoot a woman looking at a man, it will make her interest in him clear, but it would evoke a greater interest if cut from the woman to the man to the woman again.

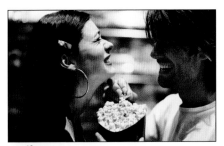

continuous action

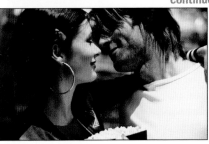
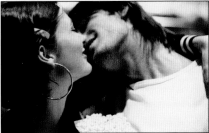

Types of transitions

There are various kinds of transitions that allow one scene to move to the next, one sequence to another, or from part to part with greater fluidity.

Cut

This is the most basic transition. Two different images are spliced directly. The transition is direct and aggressive. Use when the transition has no significant value by itself or corresponds with a change in perspective. There is no interruption in the soundtrack.

Fade

In the fade-to-black, the image progressively darkens until the screen is black. The next shot begins in darkness and gradually brightens. There was a time when it was virtually required to start each scene with a fade-to-white and finish with a fade-to-black. The fade-to-black is accompanied by a stop in the soundtrack and marks a change in time, an important change in the secondary action, or a change of place.

Cross fade

This consists of one image fading and the next slowly appearing. It is a smooth transition and it is used to suggest that, although some time has elapsed, the connection between the two sequences is strong. The cross fade is used to move from the present to the past or the present to the future. The cross fade is also used to smooth transitions in case there are many subsequent transitions. The cross fade is complemented by an audio cross fade.

Sweep

When using a sweep it is necessary to know you will be doing so during the recording of the take. When the scene ends, the camera moves with a quick, panoramic speed that does not allow anything to be seen. It serves to mark a lapse in time or to show what is happening at that same moment in another place.

Blur

The last image progressively loses focus while the next image, initially blurred, is slowly brought into focus. It is used to mark the passage of time, to introduce a past memory, or a dream.

Wipe

The new scene enters the screen laterally or horizontally. It produces a striking effect, is not very natural, and is usually reserved for television ads or music videos. There is also the iris, widely used in the silent films era, which is a circular aperture that grows or shrinks. Computer editing programs allow many more transitions.

Artificial connections: analogies

The connections are supported by an analogy, whether artificial or psychological.

Analogy of material content

The base of the transition is the identity, similarity, or relation. For exam-

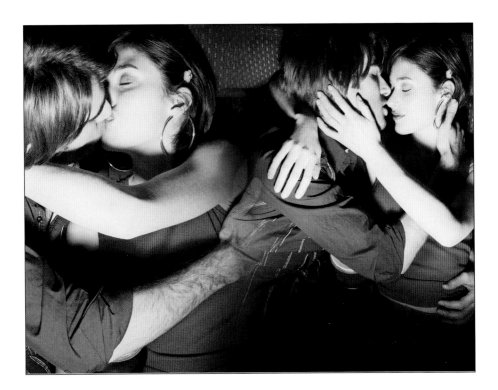

ple, move from a toy train to a real train; from a letter to its destination, or from a letter to the person who wrote it; from a girl with a doll to a woman with a baby; from the wings of a bird to a plane.

Structural content

The similarity should be the internal composition of the image: for example, move from the image of a ballerina spinning to rings of rain in a puddle, or from a rush of water to a multitude of people leaving a popular dance.

Dynamic content

Dynamic content is based on movements analogous to characters or objects. Among the most prevalent, for example, would be the glove of a stripper thrown to the public and the glove of a housewife, wearing a kitchen apron, thrown into the sink.

Remember that the possibilities are endless and they only rely on your imagination.

Psychological connections

Similar nominal content

A close-up of a word evokes a place, time, object, or character that is seen in the next shot.

Intellectual content

It reflects the thinking of a character and their correspondence with reality. For example, someone can ask themselves, at the sight of an empty bed, where another person is and it becomes clear when you see the second person in a bed with the sheets a mess, recognizable to the audience, in the room of another character.

Some advice on handling the camera

The camera

Before you really begin to film, keep the camera in the environment where the action is going to happen so that you can acclimate. Certainly, before recording the first scenes of your movie, you should know how it works.

When rolling, make sure that there isn't any ambient noise. If you have to film on location, choose a more quiet time, and if you shoot indoors, unplug refrigerators, fans, air conditioners, and other noisy appliances.

The takes

Don't spend forever on your takes. Nothing is more boring than shots where nothing happens. Be critical during editing and if too much time has passed during a take, cut it mercilessly.

Don't be afraid to do things again if the result does not satisfy you, or film some filler footage just in case. It is better to reassemble the set and get into position again. After you start to edit, you will realize that filming is not as easy as it seems and you will find that footage that you once thought was perfect does not always fit in.

As you are filming, you will be polishing as you go. When you film, have a vision of what you are recording with a critical eye before you move on to the next take.

There is a direct relationship between the size of a shot and its duration. The larger the size of a shot, the more time it will take he viewer to watch the image and grasp its meaning. A detailed shot needs a little time to unfold for the viewer.

Zoom

The zoom should not be too fast because, otherwise, a scene blurs and will cause dizziness.

The difference between tracking and the zoom is that in this case, the camera does not move and the zooming in or out is produced by varying the focal distance. The zoom manipulates perspective, while tracking is in respect to actual space.

To create tracking shots you can attach the camera securely to an office chair with wheels, a shopping cart, or a platform that you can mount a tripod on.

Dollies

A dolly makes greater understanding of a character possible and makes us focus more on the character's words, gestures, actions, or expressions. A dolly back gives the impression that we are backing away from the subject. You can use it to express a character's loneliness, to dissolve him with the background, or, during the montage, to make it look like the person that you are talking to, situated across from the camera, is backing away.

Tracking

Tracking movement displaces the whole camera. The following are some of the many different kinds of tracking:

Accompaniment

In this the camera follows an object or character. In a following tracking shot you have to pay special attention to the frame.

For example, if we are following someone walking or running, it is necessary that we leave extra empty space on screen in the direction that they are running. Furthermore, the camera should not initiate the movement. Otherwise the actor's movement will look unnatural.

Advancing

When the camera gets closer to someone or something.

Receding

When it gets farther away.

Hitchcock invented a curious and effective camera movement where, simultaneously, the camera travels backward and the zoom pushes forward. In this method, we maintain the size of the actor, but not the size of the background, and it gives a sensation of vertigo. You can see an example of this in *Psycho* when the private investigator falls down the mansion stairs.

You can also do this in reverse, with the zoom pushing out while tracking forward, but this is not as effective.

Crane

Obviously, amateur movie makers do not have access to this, but it is still good to know about. The crane can move the camera in three-dimensional spaces and can film a scene in a single shot. This is what they call a sequence shot.

Digital equipment

Thinkstock

The script

The script develops a plot and indicates how an audiovisual work should be made. It has to give information on the frames, the lighting, the movement of the camera, and the movement of the actors.

The script should be detailed; then it will suggest detailed instructions for each scene. It should detail both the story (with its beginning, middle, and end) and the visual treatment of each scene and succession of scenes. The script must reach its readers with thoroughness; it is not like a novel that can spend pages describing the scenery and dialogue.

The contents of the script

Plot

It is the choice of the screenwriter, from the events that take place to the way that they are framed in time. A story is made of multiple acts. An act is a series of sequences that reach an essential point in a climactic scene and cause a change in value more important than any scene or sequence that came before.

From the set-up, which is the first act of the script and which provides the basic information that the audience needs to know about the story, the plot will grow until it reaches the climax or the resolution. As the story develops, it is important to introduce new elements to the audience to capture their interest or provide an unexpected twist.

A script should start by describing a scene, the characters that are in it, how they are situated, and the relationships between them. Don't forget to specify

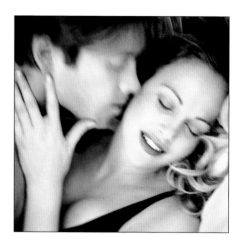

how they are dressed. You do not need to include it in the script if you use a separate notebook. This way, you will avoid unpleasant surprises when a character might wear one article of clothing in one scene and then something different later in the scene.

Continuity

You must always be sure that you maintain continuity in action, in clothing, or in a character's background. A script might start this way:

"The protagonist is lying in bed, bored. She hears a male voice. The camera turns toward the door and he appears. She holds her hand out to him and he kisses it. Detailed shot of her hand and his lips." Then the scriptwriter would continue to describe the action and write a dialogue between them. Describe the next movements (if there are any) and camera position in respect to the scene and the protagonists.

You can enrich the script with as many details as you would like, such as the atmosphere of the scene or the lighting.

The process

Idea

Something that can be expressed in a sentence.

Plot

There are several ways to express this:
- *Story line:* **in three or four lines**
- *Synopsis:* **in one or more pages**
- *Outline:* **in more than three pages**

Treatment

Only used in feature films and is 30 to 40 pages long.

Literary script

From 5 to 20 pages for short films. Each page represents approximately a minute.

This script does not have technical notation. It describes the sequences, scenes, dialogue, and contains descriptions of setting, actions, and characters' movements.

Technical Script

This follows a literary script. In it are notes that reference camera movement, sound, lighting, and so on. In film, it is not the responsibility of the scriptwriter, but the director.

This follows a literary script. In it are notes that reference camera movement, sound, lighting, and so on. In film, it is not the responsibility of the scriptwriter, but the director.

One example of what this script helps to prevent comes from a friend of mine. When it came time to edit, they realized that the two protagonists spent forever lighting a cigarette and smoking because they were embarrassed and did not know what to do in front of the camera. Even the simple act of lighting a cigarette should be specified in the script to avoid surprises.

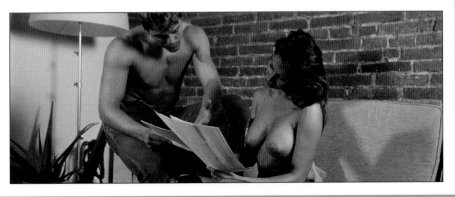

Storyboard

Because films involve a crew, everyone might have a different interpretation of the words in the script. It helps to prepare a kind of sketch to show what these scenes will look like before you begin. That is the function of the storyboard; specifically, the storyboard is the film in sketch form. It is said that the story is in the script and the film is in the storyboard.

In the storyboard a visual account of the images that will be used in the film is made. It is drawn based on the script and is a creative process that brings the first visual approximation to the film. Professionally, it facilitates communication of ideas between members of the crew.

Furthermore, the storyboard takes place on paper and allows the movie to be shaped and polished before it comes time to shoot, all in a way that uses time and resources most efficiently.

It is not essential that the drawings are realistic or well done; it is enough that the sketches give all of the information needed to shoot the film precisely and that they can be interpreted at a glance. The storyboard helps to remove blemishes from the story and to check whether something functions visually or needs to be changed. Remember the golden rule of audiovisual productions: "If it doesn't move, don't film it."

The storyboard includes different takes, camera movements, character actions, and other important details to know when it comes time to capture the images. It is presented like a cartoon, the way that you see all of the movements that come after.

Draw multiple boxes on one page

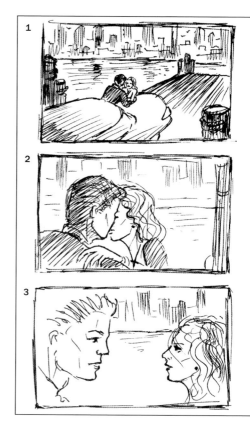

and leave space below for annotations.

Draw the scene in the boxes. For a better visualization it is more convenient for the boxes to be 4:3, the same dimensions as the screen.

In the storyboard you must also include the estimated length of each sequence. Until you have practice, draw all of the scenes of your movie with corresponding annotations over the boxes, action and visual treatment, and group them into sequences. Use as many boxes as necessary. When you have more practice it will not be as necessary to be so thorough.

Normally three boxes are used for each take, but you can use more for accuracy. Each page usually consists of nine frames.

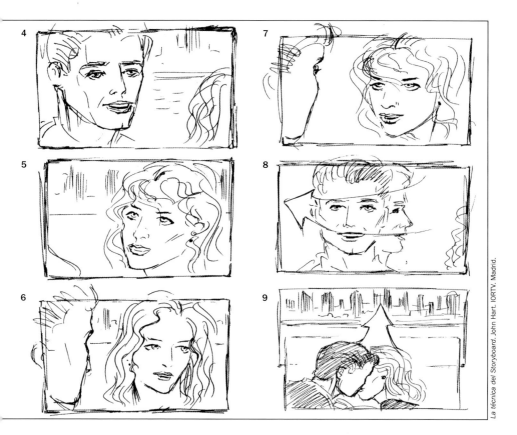

La técnica del Storyboard. John Hart. IORTV. Madrid.

You can also make more space between the boxes if it is easier to see them.

The circle corresponds to the number of the take and the box is used to specify the camera position.

Technology for the Storyboard

Currently, technology offers other options for combining images and text in a *Word* document. It is very easy to find images on the Internet that can help you to make your storyboard. Simply select the image, open the right-click menu, and select the "Save As" option. Another option is to take photos and scan them or use a digital camera. It is also possible to create images with programs like *Paint*.

Combine the images and the written directions in the *Word* document that you have opened to create your storyboard. You can copy the images to the document. Underline them and press Ctrl + C to copy. Put the cursor in the destination intended and press Ctrl + V.

Lighting

Lighting is essential, especially for indoor scenes that do not get enough natural light. It is fundamental in film because no matter how pretty a person is, they can appear attractive or creepy depending on the amount of light the camera is exposed to.

Do not abuse your camera's ability to record in the dark because your films will appear grainy. You can rent lights in specialty stores or you can use lamps and lighting around your house to illuminate the scene without paying extra. Try different arrangements with the lighting that you have at home to see which is the most flattering.

There is a classic lighting set up for indoor scenes that removes flatness, spreads light evenly, and does not leave shadows. It uses three lights.

Three-point lighting

The base light is a diffused light that uniformly illuminates the scene and is used to prevent underexposure or excessive contrast. It must be 500 watts. This light determines the position of the other two points.

The light can be placed differently depending on what is being filmed. If you are filming a scene in a room with a window, for example, the key light, which corresponds with the sun, should be set in the same window.

In a scene where the protagonists are seated in an interview format, the principal light should come from camera height, more or less in the same position, while making sure that the actors' faces are not too bright.

The second light is the fill light. It softens the shadows created by the key light. It has to be 300 watts and is situated directly opposite the key light. Because it is not as powerful, it does not create problematic shadows. You can add a diffuser to further distribute the light.

The third light (300 watts) is situated behind the actors to prevent them from appearing flat with the background.

Another trick, which only works if the ceiling is white, is to diffuse the light directly off of the ceiling. This way a greater area is lit, although the effect is more brilliant and surreal. This lighting method reduces the three-dimensional effect created by the three-point system, but it has one big advantage: it flattens the surface of the skin, and blemishes or cellulite will not show as easily.

If you combine natural light from a window with two artificial focus points, you can flatten the light (daylight tends to be blue, while lamplight tends to be orange) using a blue filter. Put the filter on the lights, but keep it a certain distance away so it does not get too hot.

If you want your scene to be hotter, cover the lens with an orange filter.

It is better to film exteriors on a cloudy day when the light is smoother and more uniform. If it is a sunny day, try using reflectors to smooth some of the shadows.

A piece of advice: do not focus toward the walls or situate any lights too close, especially if they are pink or red, because then you will seem like two lobsters cuddling.

White Balance

White balance is used to adjust the camera to the temperature of the ambi-

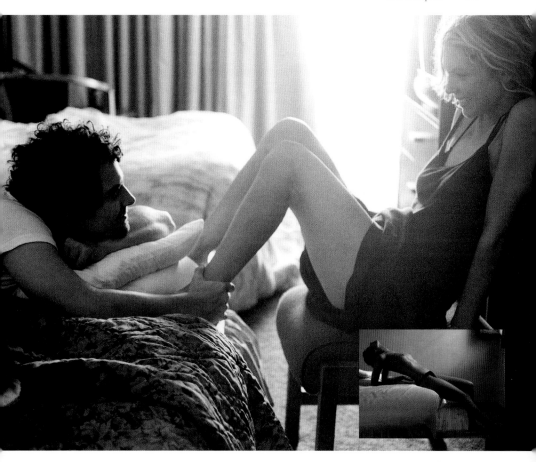

ent color. It tells the camera which color, is white so that it can identify the rest of the colors, and the images seem natural. It is convenient to manually adjust the white balance.

Exit lights, sunset, incandescent light, and candles have a low-color temperature and a reddish tone. Midday sun has a higher temperature and a blue tone.

If we are talking in terms of color, however, reddish tones are warm and blues are cold. It is necessary to have a white balance to put in front of the camera when light conditions change and when you are using complimentary lighting.

Film offers a more limited interval of contrasts than photography. High-contrast scenes are poorly lit because the areas with the most light tend to burn while areas with the least light stay in shadows.

In a scene with snow, for example, you can adjust using a filter for natural light.

Camera, action!

Important: always remember where the lights are to prevent them from appearing in the frame by accident, or worse, tripping over them and hurting yourself. The same is true of microphones and other elements that should not appear in a scene.

For your movies to seem more professional, it is best to use a tripod. Furthermore, a tripod will help in those moments when you both want to appear on film and you don't have any extra help. Be careful not to leave the frame! Always know what area is covered on camera. Adjust the height of the tripod so that the whole movie is not filmed from the same angle.

So that your scenes are not too boring or plain, there is a rule that recommends that you avoid putting the horizon in the middle of the screen, but instead, just above or below it. Decide if you want to guide the audience's attention to the sky or the ground.

The "spot center" lens filter helps to simulate a shallow depth of field. It maintains the acuity of the center while diminishing the periphery of the background. In this way, the resulting effect seems very cinematic.

Normally, it is better to manually adjust the diaphragm, especially if there is uneven lighting in the scene or the scene is lit from the back. If you want to show a person in these conditions, you should open the diaphragm according to the light emitted by the person who you are trying to film. If you select automatic,

you might end up with a well-lit background and a dark subject. This effect could be desirable if you only want to see a silhouette for artistic reasons.

Playing with the light

If your camera has manual white balance controls (this is recommended), you can create different color effects without investing in external filters or editing programs.

Create a white balance over a blue paper and you will get a very nostalgic golden sepia tone.

Create a white balance over a fluorescent tube and then film outside for a pink tone.

If you want the effect of filming in the moonlight, create the balance over a candle.

If you want to make it seem as though you are filming under an intense light and everything is dark, create the balance over red paper.

You can create a bright halo behind the subject, especially in close-ups, by putting a light directly behind them. A light that shines at them from the front will make a bright gleam in their eyes.

Checking the equipment

Make sure that the battery is charged and have an extra one ready just in case. Clean the lens of the camera with a camera wipe. Take a white card to set the white levels. Adjust the aperture and the manual or automatic focus as you see fit. Perform a few tests to ensure that the picture and sound are recording correctly. Each time that you finish a take, review the filmed material.

Help from furniture

If you are going to film without a tripod there are many other objects you can use to steady the camera: a fence, the back of a reversed chair, or a wall or doorway that you can lean against.

If you are holding the camera without support, stand in a strong stance with your feet apart, knees slightly bent, and body leaning slightly forward so that you are comfortable. Tighten the elbow of the hand that is holding the camera against your body and balance the camera with your other hand.

One time my boyfriend surprised me at home with another camera and started to film me while I filmed him

dressed in a simple, gray, low-cut shirt and white cotton panties. Then, he placed the camera so that it looked like I was recording him while he put on a show for me. He said he could not resist filming me while I was filming him because he loved the poses that I adopted and found them very sexy. I loved what he told me. Finally, we edited the film as if it was a classic first-time casting except I was the director and he was the one who wanted to get the role at all costs and would do any number of sexual things to get it.

If you want spectacular angles, lie down on the floor leaning on your elbows.

Dressing and undressing

Anything is useful to carry out your fantasies and can turn into a sexy costume.

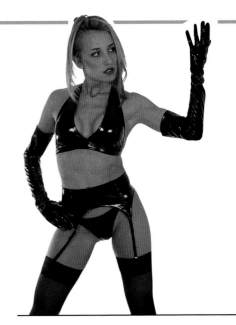

For him

- Denim, corduroy, or leather jackets
- Leather pants
- All kinds of hats and helmets (police, firefighter, baseball caps, hard-hats, cowboy hats, feather) without anything else
- Latex
- Riding boots
- Letterman's jackets
- Overalls
- Mesh or fishnets
- A spiked dog collar (with the barbs out, don't overdo it)
- A monk's habit
- Dress as a: chauffeur, a mechanic, a sexy servant, pizza delivery person, plumber, sumo wrestler, soldier, Roman general...
- An eye mask
- A cloak

For her

- Corsage
- Corsets. For the more daring there are some that leave breasts exposed.
- Thongs
- Leather caps
- Suspenders (without other clothing, please)
- Cowboy hats
- Long pearl necklaces
- Men's shirts knotted at the waist
- Men's boxer shorts
- Latex
- Tall boots
- Ankle boots
- Stilettos
- Sexy negligees or nightgowns
- Full body overalls

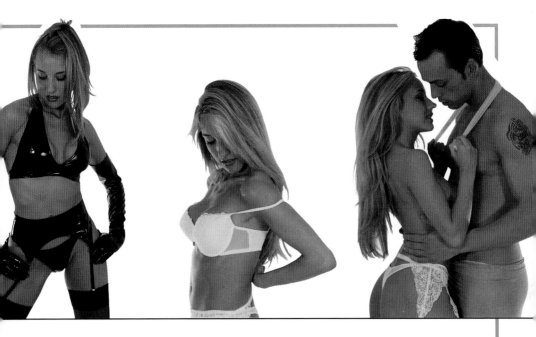

- Garter and stockings
- Stockings with strategically placed openings
- Bodystockings
- A stripper two-piece
- Pasties
- Lingerie in bold colors
- Scarves, shawls, large handkerchiefs, and other silk fabrics that make up a costume
- Dress as a: nurse, librarian, policewoman, nun, doctor, beautician, judge, and more...
- Combine biker clothes with soft lingerie
- Of course, all items in either group are perfectly interchangeable. Use this video to bring out your more hidden fantasies without worrying if they are politically correct. Combine fitted male attire with rock star makeup, like David Bowie in his glam years. Or, perhaps, combine a few days, worth of stubble with a more soft and feminine fabric like satin.

Indulge your partner. Even though it might not be your favorite fantasy, keep an open mind to their wishes and they will provide you with a new experience, making your videos much deeper and more evocative.

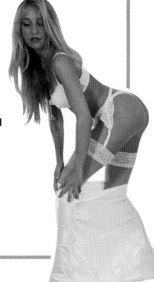

Locations

Shooting out of the house? Why not? In choosing a setting, also keep in mind that the colors that dominate a scene will give one feeling or another. Warm colors are exciting and stimulating and make spaces appear larger.

Location scouting

Explore your city, town, and countryside to find unfinished works, abandoned houses, rarely (or never) frequented architectural complexes, large clearings in the forest, old and forgotten farmhouses, mountain shanties, desert-like landscapes or a setting for your own *Little House on the Prairie*, a friend's spacious garage painted white so that you can recreate any kind of scene (you can offer to repaint at the end), or fantasy apartments (some friends loaned theirs to us after we offered to clean it), attics with a slanted roof, an office, a spacious hotel room, a shop, an intriguing basement, a library full of books… That being said, be careful not to get caught in compromising situations, found with the camera in the tripod, the tripod in your hands, or worse…

You can always use various add-ons to change the feeling of the scene to fit your needs. Obviously it isn't the same shooting a soft, short erotic film as it would be if you are filming something dirtier or porn (which we will cover at the end of the book), because then it needs to be all about comfort.

You also have the option to take advantage of your friends and acquaintances, and beg them to lend you their boutique clothing store, charming restaurant, moody bar, or whatever other fantastic location they have access to as soon as it is empty.

Shooting exteriors

If you are daring, consider using exterior settings to film your hotter scenes, but if you're afraid of being discovered, another option is to film only the softer scenes with exteriors, as a form of introduction to your video, or take exterior shots that you can then put as your background thanks to *Chroma Key*.

If you shoot the scenes fit for the public in a city, be careful not to disturb or impede foot traffic and don't directly record any passers-by. You can probably get away with filming more provocative images in front of the more well-known monuments in your city. Be careful with religious buildings: they kicked us out of one for kissing only a few months ago.

A trick: one of you two can make advances toward the camera, showing legs, cleavage, muscles, or what they are missing while the other person films. If there are people around, the trick is to do things very quickly and from different angles that won't allow visitors to realize what is happening. Then you can edit them in a succession of cuts that, additionally, will make your movies more dynamic.

I have some friends without apartments. They tell us that one time they found an abandoned town with a tiny abandoned church still in perfect condition. The door was open though inside was only the basics—a cross and a stone altar.

The town had a small, almost abandoned cemetery that even had a few recent tombstones. Well, my friends, neither brief nor lazy, filmed wild sex scenes in every inch of the town. They

dressed in the strangest clothing and even returned one night with basic lighting equipment to film scenes in the cemetery. I haven't seen the movie because she won't let me, but I think that I'll be able to soon. The closest I've come to this point is a pair of photos: one in the church, with a red velvet cape strategically covering her body but revealing her navel and the start of her breasts. The other shows her dressed in black, with her clothes in disarray in a way that made it seem like she had recently gone out to or come back from having sex, reclined in an artistic mausoleum.

My boyfriend and I have our eyes on a ghost town in the Pyrenees that only appears when the marsh that it is in is dry. It is a very scary place, but who knows, one day our fantasy may come true.

A color pallette

White

It is the color of light and clarity. It evokes purity, calm, and peace.

Yellow

The color of the sun. It evokes happiness and vitality. It is also the color of wealth.

Orange

It transmits a feeling of comfort and familiarity.

Green

The color of nature and tranquility. This is connected to hope and vitality.

Purple

This is an elegant color that is related to feelings of luxury. It is also the color of femininity.

Blue

The color of the sky and the sea, it symbolizes dignity and infinity. Refreshing.

Gray

This is a neutral color that can evoke sadness and poverty.

Black

It is related to death, mystery, power, and elegance.

It is just as important to decide your wardrobe and the impression that you would like to give (dominant, sophisticated, a touch morbid, elegant, a bit rural, juvenile) as it is to put yourself in a setting that reinforces your fantasies.

Costumes and props

This is about making the most of what you have at your fingertips. Take trips to flea markets or thrift shops, where there are clothes of all styles and colors, and you can find different clothing at very good prices. Not to mention lingerie; they are often available at great prices and now in conventional stores (not just in sex shops).

As for the sets, with a little imagination, anything is possible. Fancy fabrics can help to recreate dream rooms or even scenes from one thousand and one nights, gypsy or Bedouin camps, future fantasies, and other types of dreams.

A piece of advice: let your partner pick out your attire. Filming a sexy movie is a great occasion for each of you to confess your fantasies and see what pleases your partner. What happens if, at the end of a few months or years of a relationship, you discover his fantasy is to see you with tights with runs in them and he never told you? This video could very well be an excuse to get to know each other better.

In terms of accessories and decorations, there are many people who travel now, and it is not difficult to find

exotic pieces in our own country such as hookah, oriental carpets, fine exotic fabrics, chests from one thousand and one nights, tea sets, artisanal trays, and all kinds of furniture and props that can be used for the setting. Don't forget to visit flea markets and thrift shops or to search your grandparents' house, which oftentimes will have surprising ornaments such as trays and maricastaña crystal, great sexy antique mirrors, or retro gowns that are very "modern." Other options are to borrow the specific things that you need—the world is full of volunteers, a friend of mine says—improvise or be aware of when an old apartment is waiting for you.

One time my boyfriend and I had a great time dressing and undressing each other in true caveman style. Our video includes a banquet where we feed each other all kinds of foods with our hands, such as fruit and even a shoulder of lamb. It was very fun; we turned our room into a cave with stalactites and stalagmites, and cave paintings that we made on wrapping paper. We made some of them live and even painted each others' bodies. We also imitated the roughness of the cave with wrapping paper, and my boyfriend, who is the handyman for our sets, made a small waterfall-like fountain.

Filming it was wild and full of laughter, which we always allow, the most primitive sensuality, with wild gestures and enjoying every moment of hedonism. In the video, two beasts (us), with all of our senses, took pleasure in all of the most basic and voluptuous joys that life gave us. A few times we used paintings or used cream and jam to feast on each other's bodies, but the act of performing for the camera and finding

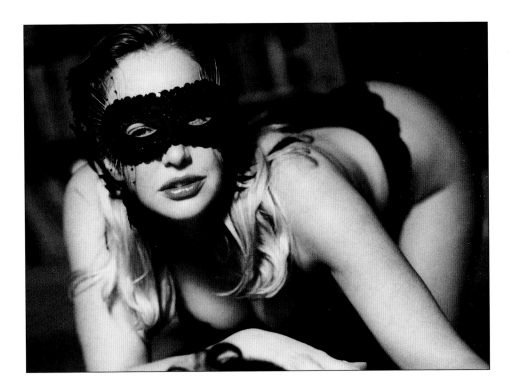

our best angles, and making it visually exciting was a completely new experience.

After, my boyfriend told me that he had rediscovered the softness of my skin when caressing me with the furs that were covering my body, and I had discovered a new sensuality feeling the soft caress of those furs. Note: we used fake furs because we are both against the killing of animals.

The scenes where we bathed each other were particularly intense. We spent a lot of time trying to decide on something, but we finally found a small waterfall and went there one weekday morning. Really, the fact that we both work from home is very convenient when it comes to shooting exteriors.

We splashed each other with water from coconut halves and, after we were already very wet, we went under the waterfall and started to undress. We didn't dare go too far (certain that my friend, who made the video in the cemetery, had gone too far), but in that moment we really let go.

The moment that I found particularly sexy was when he started to comb my hair and give me quick kisses on my neck and shoulders. When he untangled my hair, he started to slowly run his fingers through my hair and my neck giving me little shivers. (Mmmmmmmm....)

Editing analog video

Speed is at odds with good production. The step between one shot and another (the transition) has to be progressive and at least have a justification or clear purpose. This does not include music videos, which have a more upbeat rhythm.

If you have an analog camera, you have two options for editing: analog editing or nonlinear editing for which you are going to have to use a PC for what you've recorded.

To do this you'll need an analog video input. Many TV tuners have this, for example *Pinnacle* PCTV.

There are many programs to do this, for example *Virtualdub* or *Virtualdubmod*. The first has a file size limit of 2 GB and the second up to 4 GB. The best way is to capture in a separate NTFS file partition.

This is how you would do it:
File > Capture AVI
File > Set Capture File: you put the name and where to save the archive (NTFS roolz)
Audio > Compression: Best PCM (wav), CD quality (the preset)
Video > Select Overlay
Video > Format 352×288
Video > Source: Here you should select the input source of the video. To go from VHS to AVI, the best way is to use S-Video because it is the highest quality. If you do not have an S-Video input, you can use composite (composite video)
Capture > Settings: frame rate 25.0002. Select capture audio and remember to unselect quit with the left mouse button.

Capture > Capture Video (F6): Starts the capture
The capture ends when:
Your hard drive runs out of space.
You manually cancel it.
It reaches the limit of the FAT32 card.

Once the process is finished, you have an uncompressed AVI file. It will be very big and hard to move, but this way it will have the highest quality after it is compressed with the codecs you need and edited.

Once it is edited, you can watch it on your computer, most tabletop DVD players, and VCD players. To watch it on VHS you will need a video output on your PC.

Linear editing

All you need is a camera and a video. You can also use titlers and a special effects generator and produce effects like color negative, solarization, superimposition, overlay, inserting titles that are giant letters filled with images from a separate take...

Connect the camera and the video player (audio and video cables) and connect the video to the television.

Before you start to record, make a list of all of the shots that you want and in what order you want them to appear. Find all of these shots in the original tape.

Load a blank tape into the video player, let it play for thirty seconds, and stop the recording. Find your first shot on the recorded tape and rewind the tape a few seconds.

Turn on the camera. Just before the start of your first shot, press unpause and record. Record a few seconds past the end of the take. Pause the video player

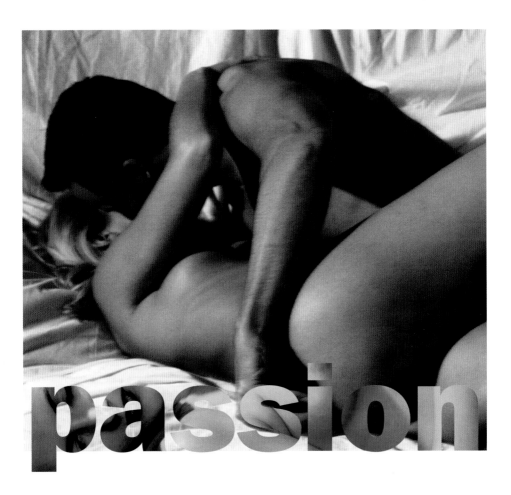

and stop the camera. Replay the edited shot to ensure the accuracy of the take. When it reaches the end point of the shot, press pause. Prepare another shot. This technique is very basic but not very precise. To make editing more exact you can use an editing controller.

To combine the sound from the video with other elements, connect the camera to an input on the mixer with the other sound channels. Double the resulting channel onto a new tape and play the frames directly from the camera to the edited tape.

Editing digital video

To edit your videos shot with digital cameras you have three options:
• Run the videos to the computer through an analog video capture device that can compress to m-jpeg or mpeg-2; edit and place the result onto VHS, DV, CD-ROM, or DVD-RAM.
• Upload the digital video to your computer via FireWire; edit and rewrite the video to the DV tape through FireWire. This is the best method.

• Make any edits directly on the VHS or DV tape and use the software normally packaged with the camera. This is the most basic method.

With the study of a manual on video editing and a little practice, it is relatively easy to manage an editing program. Keep in mind, however, that these are not intuitive programs; before editing one of your own videos you should follow their tutorials to learn all of the tricks.

Digital Transitions

In addition to classic transitions, digital editing makes other, more imaginative transitions possible. They can be divided into two groups: 2D and 3D. In 2D:

Wipe. Image B is revealed underneath image A in vertical or horizontal bands.

Checker Wipe. Two sets of squares are removed to reveal image B.

Clock Wipe. A bar coming from the center of the screen moves in a circular motion, revealing image B.

Diamond, Star, Cross, Polka Dots. A transition in a geometric form revealing image B beneath image A.

Wipe Dissolve. A moving bar reveals image B.

Doors. Image B swings over image A vertically or horizontally.

Funnel. Image A pases through a tunnel revealing image B.

Page Turn. Image A turns over with a darkened reverse side to uncover image B.

Big Fish. Image A turns into a small fish that is eaten by a bigger fish containing image B. The big fish expands to fill the screen.

Billiard Balls. Image A turns into a set of billiard balls that are hit off the screen to reveal image B.

How to edit

First, you have to have precise shots that match the storyboard that you have already created. Once you have all of your scenes filmed, copy the digital video to the computer via FireWire. With digital video, unlike analog, there is no loss in quality.

This is best done in smaller packages to avoid overworking your computer.

For video editing, use Adobe Premiere or another editing program.

To add transitions, filters, or titles, you have to decompress the images and treat them as RGB bitmaps. This should be easy to do, as it can be done with a codec software that is generally already installed. Once the transition or filter is done, the codec will recompress the video into DV format.

If you want to add filters to the whole video (for color correction or to give a special look to the film), the process can take hours. If you want to speed up the process, the only solution is to buy better hardware.

An editing program allows you to add video effects, audio effects, and titles with up to 90 fonts, mix audio, create masks to hide unwanted parts, use transparencies to create compositions, animate a clip with movement on the screen, and much more.

It is often better to add the sound when editing because it will be more uniform. If it is a song, plan the shoot so that you have enough shots to illustrate it. The disadvantage to adding sound while editing is that if you are filming a striptease, the actor or actress will have to dance in silence, but with trial and patience, it can be overcome.

Once you have finished editing, you will need to put the resulting video back on the camera via FireWire.

Digital effects

With modern editing programs, it is possible to use a large number of transitions and effects to give more expression to your videos. The key is moderation: if our videos are not saturated by effects, they will be better. Always follow one rule: do not put anything in your movie that has no reason to be there.

Thanks to editing suites like Adobe Premiere, there is a lot that can be done. In addition to effects, such as pulling still images from a video, changing the background for a dream sequence without leaving the house with Croma key, or altering the speed of your videos, you can treat each clip (each part of the video that you are working on in any given moment) with filters. There are hundreds of filters, and the program also allows you to create personalized filters.

One filter, for example, can soften the skin of the people in the video so that no irregularities or less attractive areas appear. You can apply multiple filters to each clip.

Adjustment Filters

• **Move pixels.** Crop lines of pixels around the border of the clip. The cropped area is filled with a preselected color. This is useful for eliminating distorted pixels.

• **Crop.** This is similar to the first because it also removes unwanted pixels, but this filter automatically resizes the clip to its original size.

• **Anti-alias.** Averages colors in areas

of high contrast by adding intermediate shades. Transitions between dark and light areas are not as sharp.

• **Change horizontal and vertical axis.** Flip the image from left to right or upside down.

• **Pan image.** Crop any part of the image in a way that you can alter the position and size during the clip.

Image Control Filters

• **Black and White.** Creates an image in black and white, reducing all of the colors to shades of gray.

• **Brightness and Contrast, Tone and Saturation, and Color Balance.** Serve to control the color values.

• **Camera Display.** Reduces the luminance and saturation levels so that an image can be properly seen in a television broadcast.

• **Gama Correction.** Lightens or darkens an image without changing the color contrast.

• **Levels.** A combined filter for brightness and contrast, tone and saturation, color balance and gamma correction.

• **Color Pass.** Changes all of the colors in a video to black and white with the exception of one color. A good example of this effect is the girl with the red coat in *Schindler's List*.

• **Color Replace.** Changes all instances of one color with a new selected color.

Modification Filters

• **Blur.** Has a wide range of intensities, from subtle to more extreme. A typical application is to see through the eyes of someone who has lost their glass-

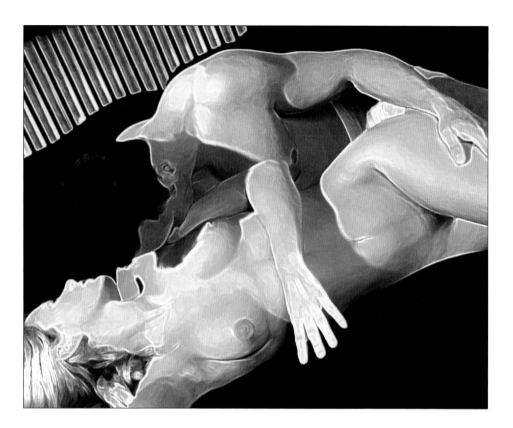

es, or because of their surprise, they are unable to focus.

• **Reverse.** Plays the clip backward.

• **Motion blur.** Superimposes previous stills from a clip to create a ghostlike effect.

• **Flash.** Imitates a burst of bright light reflected directly on the lens of the camera. This serves to highlight an object moving on the screen.

• **Solarize.** Combines a positive and negative image to create a halo effect.

• **Inversion.** Changes the colors to create a negative image.

There are also more artistic filters that have effects such as crystallization, emboss, mosaic, or can sharpen the edges of each element that appears in the image.

Distortion filters are often used as transitions between clips:

• **Squeeze.** Collapses or crushes an image from the edges toward the center.

• **Ripple.** Creates a wavy pattern like a water ripple.

• **Replicate.** Creates copies of the image and shows them as a mosaic.

• **Spiral.** Makes the image rotate around its center with a swirl effect.

Some "professional" tricks

You will be the "actors," of course, but in some of my less daring suggestions, such as music videos, you could solicit the help of your friends.

It is important that you get the best out of your video and that you feel happy about seeing yourself on camera. Find your best positions and the best way to capture them on video.

Don't wear tight clothing before you film. If you are going to take off your clothes they could leave ugly marks. This includes socks, underwear, and tight pants.

Stylize your bodies. An excellent way to do this could be to put the camera underneath her while he is sitting on the couch and she leans over to kiss him. Her long legs and butt in a close-up and her stylized body will leave an impression.

Makeup

It is essential to use a few beauty parlor tricks to appear stunning on film. If you want to regain a youthful complexion in minutes, squeeze half a grapefruit, mix the juice with a beaten egg, apply it to your face, and let it sit for fifteen minutes. Remove with warm water.

To make your eyes look bigger (an effect you will always want unless you have bulging eyes) the key is in the eyelashes. Apply a loose powder before using mascara so that they appear fuller. Apply from the center out, from the closest to the nose outward.

You can hide veins, pimples, and other imperfections by applying a little (yes, a little) green shadow on them. Cover with makeup.

An erotic video demands full lips. Before applying lipstick, moisten them with some Vaseline, then use a lipstick with a shine, glossy or wet, both are fashionable and appropriate for filmic fantasy.

A secret: don't highlight more than one part of your face. If your eyes are your strong point, bring them out more with some makeup. If it is your mouth, emphasize it. You can use makeup to bring out another feature, but it is important to use makeup in moderation. Don't use too much blush; just give yourself a light dab on the cheeks.

You can also have some fun and give yourself exaggerated makeup (it's a game!) to look like a prostitute or a tramp. Or like Cleopatra with expressive lines of kohl on her eyes.

Once we both dressed and made ourselves up like drag queens with false eyelashes, long painted nails, fantastic dresses, and impossible heels. We went out dancing like we saw in a show. Just for the occasion, we even bought a disco ball that we found in a dollar store and some psychedelic lights from the same place. In the middle of the show we started to dance, strutting and rubbing against each other. The high heels, wigs, and makeup gave us a very special look. A little funny, but sexy, something very different from our usual selves.

What's more, as we started to take off some of our clothes—even though we weren't particularly covered, to be honest—the differences between the two

of us became more apparent and the resulting video was very exciting.

Both my boyfriend and I have realized that having a voyeur or even imagining one excites us. Later I will tell you about one of our most daring fantasies to date. I am talking about a fantasy that has turned into a reality. Also, later, we will film ourselves as two drag queens but in a sappy TV show (like the ones that are made for housewives) and, to the amazement of the audience, we start to touch, fondle, kiss, and caress.

In these situations, I can't help thinking about my more daring friend who would drag an audience member on stage for one of her hotter shows.

Body in form

To have your body appear at its best in your videos, you can do something as basic as mixing a few drops of makeup with a hydrating cream and apply it with a sponge. Remember, it isn't about giving yourself a tan with layers of cream as much as it is about having a more uniform skin tone.

This is especially important to keep in mind if you are going to use makeup on your face and bring out your neckline or you are going to show a lot of skin.

For her, there are many options: Something like a Fluide Etincelant, a smooth gel that spreads easily and adds a slight gleam. Apply it to the parts of the body that you are going to see.

Another example is Luminous Effect from Nivea, which keeps your skin soft, silky, and smooth, and has special pigments that reflect light and enhance the natural glow of the skin. Stimulating vitamin C lotion from The Body Shop moisturizes, softens skin, and prevents sagging (this is preparation that you should do at least ten days before the first scene).

There are things that you can do to hide wrinkles and blemishes, and make your face and skin appear smoother on film. Lens filters can accomplish the same things as editing filters can, but with more respect for the details.

Here are a few filters to note:

- **White Promist 3.** Lights and windows will have an ethereal glow. Whites, areas of light, reflections off of metal, and crystal or jewelry will shine.
- **Soft F/X3.** Gives the film a soft magical look and makes lights and white shine.
- **Warm Soft F/X.** Gives the film a warmer look and can make the actors appear tanner.
- **Soft F/X 4.** Gives the film an ethereal, dreamy look.
- **Promist 1/2.** Gives the film a foggy look.

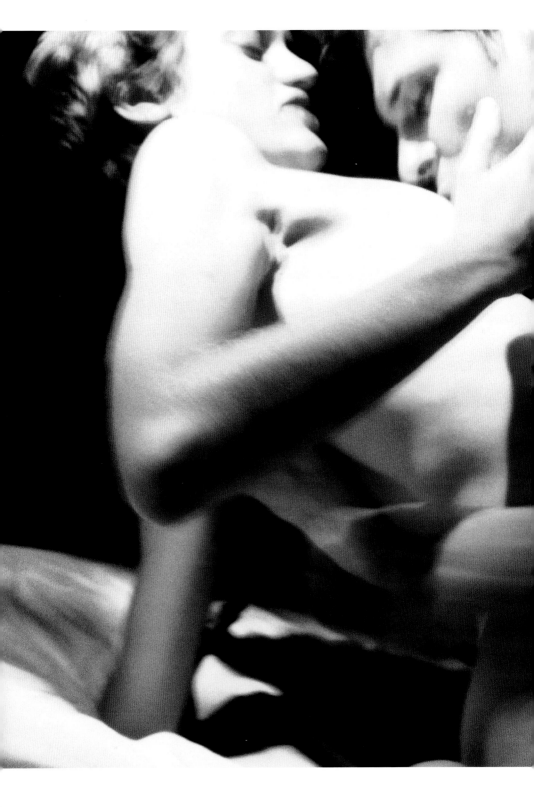

The Garden of Earthly Delights

Visual Promises

Caught in the act

You can show the guy in your movie doing something he likes. If he is a gardener, he can wear some sexy denim overalls (without a shirt underneath) and a straw hat. If he likes motorcycles, make your own version of a men's cologne ad, with a black leather jacket, and have his pecs showing at the end—if he is hairy, careful with the zipper . . .You can mix in scenes at the office, showing him at work, so that his transformation seems even more wild.

There are many *interesting* activities that men can do to show muscle: for example, stack bricks to make a wall, march, dance, gymnastics, mix cement, bring water jugs to the apartment—a classic, the water delivery man—work in the garden, do the laundry without a shirt, make and unmake the bed, and also, put oil on his arms and chest, which will make his skin glow and his muscles stand out. And of course, break time. What could I tell you that you don't already know about the *Coca-Cola* guy and those shots of his chest and shoulders that (wonderfully) seem to last forever?

The success of the *Martini* guy is mostly in his characteristic gesture. Don't try to imitate it, but try to find your own seductive gesture. There is no one better than your partner to find it for you your partner knows how charming you can be with a certain smile or a seductive wink, or when you brush back her bangs with a hand or lick your lips. There are many very seductive gestures.

Do you need more ideas? You can become a go-go dancer and dance with tight clothing that moves with your body.

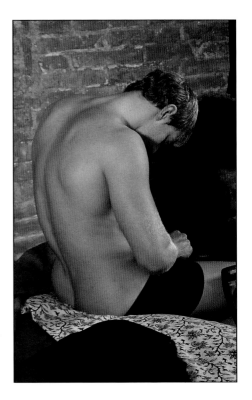

Pelvic movements look great and also prepare you for when you might need them.

You can also start as a man from the 1940s, and become, with each article of clothing, a man of the 21st century with tight-fitting pants and a tight or fancy shirt. You can tell the story, for example, of a man who flees the past and finds the woman of his dreams in the present.

If you are daring and, keeping in mind that this video is for your own consumption, the woman can pay tribute to her partner as she watches through the camera as he undresses and begins to slowly touch himself. Between scenes of slow male nudity, intercut shots of female hands with long, painted nails touching him. You can recreate a fantasy of the female lead filming her partner however he likes it. Let your imagination run free.

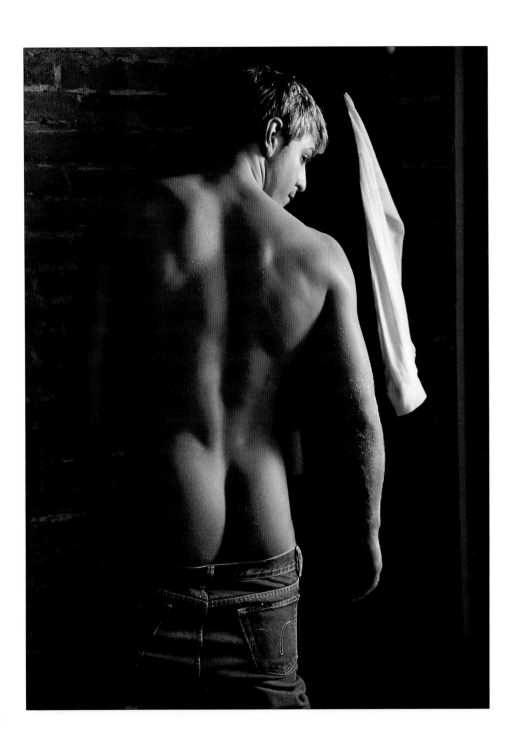

Drama

I once asked my boyfriend to dress up as a thief with a mask and a long cloak, under which he wore black tights and a tight black shirt. The loot that he was leaving the house with was an "expensive" evening dress covered in "diamonds."

The mansion where the owner of this evening dress (me) lived could easily be entered, but the only way to leave was out through the door, past a guard. The best way to take the dress then was to wear it and leave as if he were one of the house's owner's many friends. The thief entered the large dressing room, full of clothes and two magnificent mirrors, and could not avoid doing a striptease to take off his clothes and put on the dress that he was going to steal.

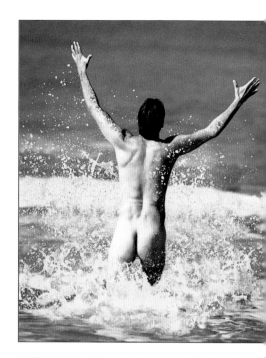

Just as he had finished dressing, a noise alerted the owner. To escape, the thief seduced her. Sure, it is a bit odd that she welcomed his advances after finding him wearing her dress in her closet, but that is part of the male fantasy and this is not the place to question it, just enjoy it. Would you like to be irresistible and seduce a woman simply with your presence, even late into the night, so she falls at your feet? This video is, of course, the best way of making that a reality.

The man in the couple does not want to cross-dress? I can't believe that; the majority of men, as we see them in parties, carnivals, and other forms of revelry, go crazy about dressing as women, especially when the prize is that they get to undress a real woman themselves. We don't speak a word between the two of us; the thief simply guides me with his gestures, demonstrating his dominance and virility.

You also would not believe the effort it took to sew the "diamonds" into the evening dress, but it was worth it.

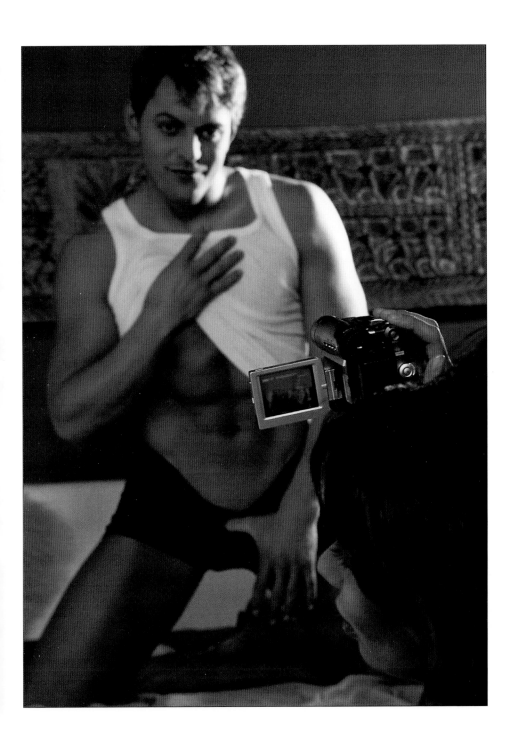

How to save the movie in editing

Most likely your first movie will have many sudden camera movements, will be shaky, abuse the zoom, be blurry, and have the wrong white balance. Those are mistakes that you will start to correct little by little in subsequent recordings, but in your first production you are going to have to fix them in editing.

If too much camera movement is your problem, you can use a strobe effect called *Posterize Time* in *Adobe Premiere 6*, which freezes some frames and skips others, creating a very artistic effect. To avoid skipping frames, you can also reduce the speed so that it plays in slow motion. This will increase the expressiveness of the scene.

If the white balance was off, you can correct it with the *Color Balance* filter and adjust each color individually. In a low-light recording, you can use the *Bright & Contrast* filter to increase the brightness.

If zoom is overused, cut the middle of the shot so that only the beginning and the end of the clip remain. This way, in place of a zoom in or zoom out, you will have a cut.

You can also experiment with using a tripod to film your scenes. Scenes filmed with one may appear more serious and professional, while scenes filmed without it can give the effect of being the point of view of your partner.

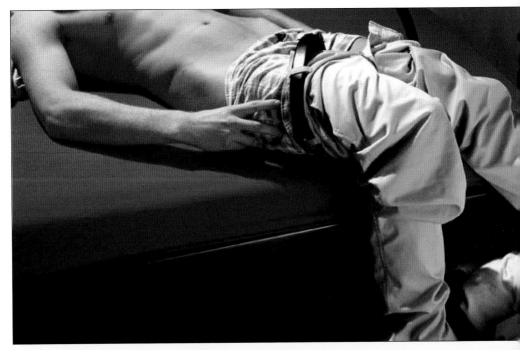

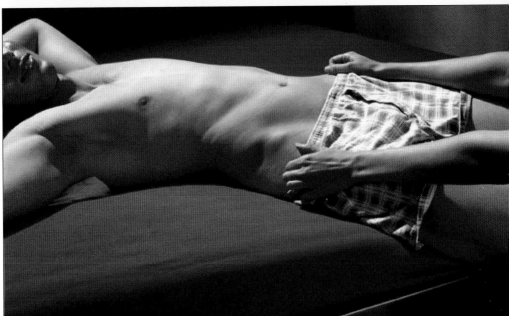

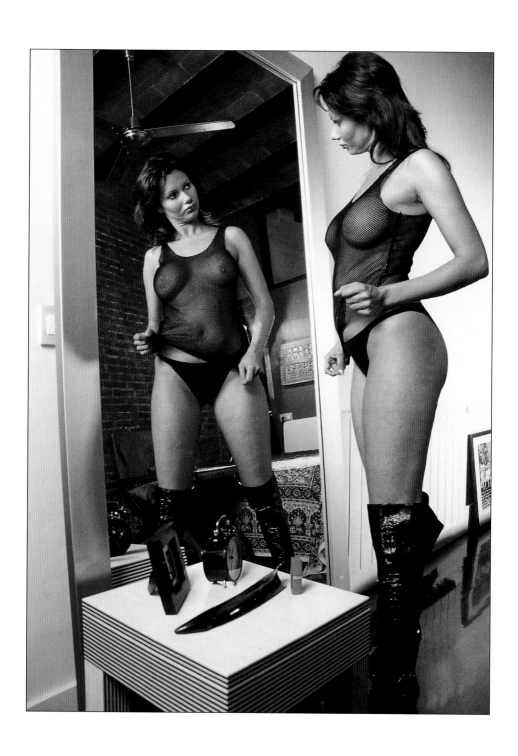

(Almost) alone with myself

Your first time with the camera should be something simple: she shows her profile and shape, moving suggestively and giving a spin around as the camera follows her and pauses at certain parts of her body.

An important recommendation: The light should never, never, never, come from below because it will bring out wrinkles and cellulite, and make you look a little bit bigger. It isn't something to get obsessed over, but you should make yourself look as attractive as you can.

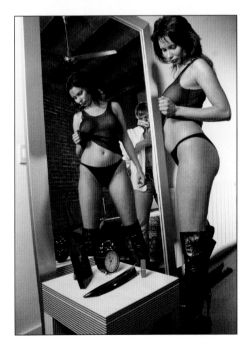

To feel more uninhibited, she can role-play as someone else and wear dresses that she would not normally wear. You can be accomplices in this and take a trip to a lingerie store, a sex shop, or anywhere else that might have clothing that is very different from her normal style, and choose an outfit together.

You can tell a story: perhaps while she is waiting for a call, she has a rather erotic dream, or she wants to call her love but cannot bring herself to do it, and when she finally is about to leave to see him, she opens the door to find her love (you).

There is nothing sexier than a woman getting ready to go out or a woman undressing, lost in her thoughts, who lets her hair down, looks in the mirror, and likes what she sees. Make the camera love you! And to the person filming: make the camera reflect your desire! Another option: she tries on a few dresses to decide what to wear for a date. The editing has to be quick with

dynamic cuts, and can show the parts of her body that stand out with every dress, like the neck if it is low-cut, a leg if it is a high-slit skirt, a butt if it is a tight dress, the back...

Use some detail shots to personalize your video. For example, with her full, painted lips, she can say, "Love." Film her face in a close-up and then ask her to repeat it, this time with only her lips in the frame. In a video where there is only background music, you can add your voice in at those moments. You can also think certain sentences aloud and give clues about the story that you are telling.

Most importantly, there should be movement, and even if you do not have a clear story to tell, you need to keep the audience's attention as more of the woman's body is revealed. More ideas: She can be dressed in black, with a veil that covers her face (as if she were mourning), and undress slowly until she is only wearing the veil, shoes, stockings, and a garter.

It is not about doing a striptease yet, as much as it is finding the best angles for the artist to learn to love his or her image on the screen, to practice moving naturally, and for the person who is filming to learn how to look through the lens and capture this.

Another option is for her to start dressed as an innocent girl and, with a few touches here and there, become a vampire. A good example of how to make a dress sexier in a snap is in *True Lies*, where Jamie Lee Curtis cuts her skirt and tears the sleeves of her dress to appear bolder.

Even more ideas: make it about him watching. She can start completely naked and he can begin painting her nipples in honey powder, putting on a bra, ordering her to put on panties, a blouse, a skirt . . .

His hands should caress her body with both familiarity and authority.

Finally, the makeup, and when it is ready, she can suggestively unbutton a few buttons from her blouse, take out her breast, and start to caress it.

The camera should be on a tripod, but you can stop the action to adjust the zoom, modify the frame, or move the camera. Pay attention to continuity! Even though you are going to edit what you record, if he is putting on the bra on one side and then appears on the other side after a cut, you cannot fix this. It needs to be consistent.

Once, my boyfriend and I improvised a device so that we could film without holding the camera in our hands. We attached it to a hard hat that my boyfriend wore; it was as if the camera saw what he was seeing.

We knew that we were going to need wider shots to mix in or some other point of view, but our focus was on the pleasure. Initially I was only going to get naked and expose myself to him, but his hands on my body and the knowledge that everything was being filmed had me up to one hundred. To my delight, he broke his promise not to go too far and completely undressed me. He oiled his hands and began to explore my body, with special interest in my stomach, the start of my pubic hair, my thighs . . . I was dying for him to continue and he did, slowly stroking my genitals. I tried to touch myself at my own speed, but he held my hands together and said, "No."

He started to masturbate me, watching my reactions and the reactions of my body. When he slipped a finger in my vagina, I could not take it and I came immediately.

I wanted to please him, but he kept my hands together. He put the camera,

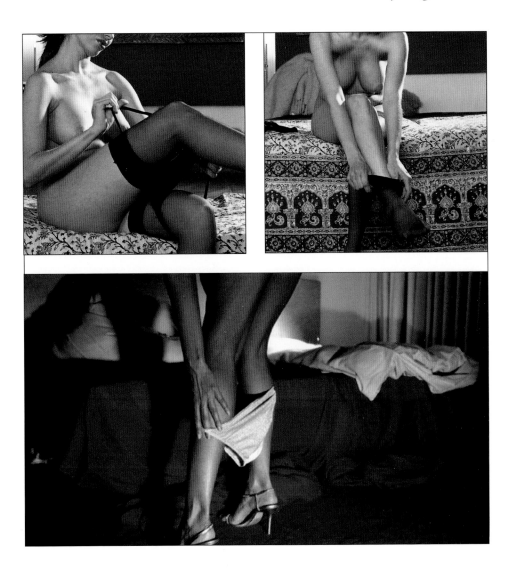

still attached to the helmet, on a piece of furniture, so that it would capture my profile, and then he stood in front of me and started to masturbate for me, so that I could see him, but I was not in the way when the time came. He didn't last very long either.

At first we imagined that our videos were going to be erotic and insinuating and that we were not going to film any-thing explicitly sexual, but knowing that we were filming turned us on and what began as a small memento of our bodies became a memento of our intense sex life.

Reflections in the water

Water is a common element in erotic videos and audiovisual productions in general. In fact, the four elements can each provide a lot to the proceedings: wind, even in the form of fans that blow hair and clothes; fire, which gives strength and power to images and introduces a disturbing and dark feel; and earth, which evokes a union with nature, and offers, in all of its various landscapes (cliffs, canyons, sprawling grasslands, mysterious forests, or deserts) an exceptional setting in which to enjoy a view of the human body.

Water can add a playful element to your erotic video. You can throw buckets of water at each other or just tiny drops, you can spray each other with a hose, splash each other from a fountain, it can be a veil of water thrown in front of the star using a pitcher, you can dip your toes in it, or it can fall from above like the legendary scene in *Flashdance*.

You can find water in many different landscapes: rivers, waterfalls, swamps, seas, reservoirs, pools, ponds, fountains, and of course, baths and showers.

If you decide to show your partner showering or playing with water, pay special attention to detail and create your own original images. For example, find a single drop of water on your body and follow it with the camera. Make several drops of water follow one another in these paths. This can be a prelude to the shower.

A shower can be filmed in many ways, in the bathroom, decorated for the occasion, or outside, with the star in soaking-wet clothes, or naked, or both; you can start the video dressed, let the clothing get wet, and then begin to take it off. Suggested clothing? It can range from a suit for him or a suit jacket for her to very tight-fitting clothes for both of you, like short shorts for him, under which he is wearing a thong, and a top and miniskirt for her.

Another possibility? Do it Angelina Jolie style, a home video completely recorded in the bathroom mirror. Just don't be evil and spread the video around the Internet like Angelina's partner did.

Underwater

If you are divers, have friends who are divers with the proper equipment, or simply would like to start exploring the ocean, and would incidentally like to start incorporating underwater shots in your videos, you will need the proper equipment.

To keep the camera under the water or keep it from getting wet in the rain is complicated and a little expensive. The deeper under water, the more expensive it will become.

There are two accessories for underwater use: a protective case and auxiliary lighting bulbs. You can dispense with the later, but not with the protective case.

For filming underwater, the best time of day is noon, because the light will penetrate the water at a perpendicular angle so it will have to travel a shorter distance to the subject. Poorly lit underwater shots will have a blue tint because seawater is a powerful filter. This can be improved by using as close an angle as you can get to minimize the water's filter. Additionally, the shots will be less blurry. You can also use an orange filter

to prevent cooler colors from dominating the picture: "Anti-blue" for tropical zones and "anti-green" for the Mediterranean ocean.

Two more things: when filming underwater, forget about zoom and prevent condensation on the lenses by putting silica gel into the casing. Many cases will include an underwater microphone (hydrophone) that provides a more realistic sound that you can take advantage of in editing. It connects with the mic input on the camera.

The cases will not let you reach all of the buttons on the camera, only the main features.

Female striptease

Props are central to a striptease: feather boas, pearl necklaces, garters, fur coats, raincoats, negligees, serious outfits made up of several layers that will come off little by little, angora sweaters, men's ties, flowers with which to cover yourself where appropriate (for example, sunflowers), shawls, and sheer fabric...

Additionally, a striptease is a good workout for both of you because the person with the camera has all of the freedom in the world to experiment and can focus on getting different points of view of their partner. It is important that you film enough material to use for editing after it is filmed.

Take off your clothes slowly, let a strap fall and pull it back up, unhook the back of your bra and let it slip off. You can also take off your clothes to music; choose something rhythmic for this and time your movements to the beat of the music.

There are many possibilities for a striptease. There are "professional" moves that you can easily make. It is amazing how simple they can be to do.

A key for both male and female stripteases is in the hips and the waist. All hip movements are sexy: in circles, in circles combined with bending your legs to lower your body, sideways, rhythmically back and forth...

You will find it very easy; it's all about the rhythm, playing with your waist and abs. Tight circles with your waist and quick movements back and forth require a good set of abs. Pair these

with arm movements: bend your elbows, put your arms up so that the palms face outward, and open and close your arms to the rhythm of your hips. Turn all the way around so that you see all of yourself and do sexy poses like lean-forwards while you turn your back.

I am not a professional stripper, but with a little bit of interest and practice, and from watching strippers, I have learned to take advantage of my body, and, above all, dance without inhibition. That is sexy. If you dance like crazy with a friend in a nightclub, it is a sure way to attract a lot of men. This is because they will see that you are free and confident in your body like two wild animals. You can also turn this into a fierce dance of intimacy with your partner.

Learn what you can get from your body. If, like me, you have bigger breasts, learn to show them off. Gently bend your arms, relax your body, and shake your shoulders to jiggle your breasts in a tempting way. Of course, this is much more effective if you are wearing a gorgeous bra or stripper outfit.

Even if you aren't a great dancer, if you learn to move your hips in different ways and show different parts of your body, you will be sexy. But you also have a great advantage if he already thinks that you are sexy—if you work even a little bit on a dance "for him," you will be even more so.

Another very basic trick that is extremely provocative is to walk on all fours toward the camera as it simulates his point of view. Another possibility is to walk on all fours and the camera will film it from the side.

The floor is a great way to move around and get in position: lie on your back, lift up your legs and spread them; kneel and lean back; kneel with your back to the camera, move your hips back and forth, and then finally lie on your side; sit on the floor and spread your legs with your heels flat on the floor to show yourself; lie on your side and turn until you are facedown and then put yourself in a catlike pose with the help of your arms or push yourself back still lying down; kneel, lean forward until you can support yourself with your hands, and move like a panther, arching your back in and out to the rhythm.

Don't forget to move your arms: your hands can caress your body and make it more inviting. Be creative in your striptease: you can make a very erotic striptease by asking him to take off each article of clothing.

Choose rhythmic music, dress in several layers of easy-to-remove clothing, and provocatively move closer to him and farther away as you dance. Lie on him and move so that he can help you take off your clothes. It wouldn't hurt to practice first. Would you like to be more daring? You could do a striptease where the girl stays in her panties, bra, stockings, and garter, but there are other friends that she dances with that will take off her clothes for her.

As far as the camera goes, you are going to have to get a few different shots, with different angles and content, so that you can show her in her full splendor.

Male striptease

Who says that men can't be sexy and undress in a provocative way? Two rules: no socks and do not take off your clothes carelessly and in a hurry.

After that, anything goes, from mounting a camera on a tripod and touching your partner without letting them touch you, to using the furniture to show off new moves or showing off your muscles by doing a few quick push-ups on the floor.

Show your powerful pelvic movement: slowly, so that the camera can fall in love with your hips. And quickly, to give the film a frenzy. Touch yourself with every piece of clothing that you take off; don't rush, each new step toward nudity is exciting and allows your body to be seen in new ways: if you take off your shirt and are wearing a fishnet T-shirt, your muscles and your nipples will creep through it. When you take off your pants, your ass will want to leave your underwear and show itself in its enticing ways. You have the power to move around and show what you want.

Show each of your muscles, flexing your legs so that you show them off while you dance. Look at her and smile. Touch yourself so that she can see; provoke her. Lift an arm with a raised fist, grab it with your other hand, put your leg forward, and move your body back and forth. Borrow some tricks from the female striptease, such as the chair move, or move for her, sitting backward with your back to the camera. Leave the chair by standing on one foot, lifting your

other leg, and passing the chair below you (watch the height of the back of the chair so that you avoid hitting yourself and turning this into a truly unforgettable striptease).

When one of you is doing a striptease, the other can help by breaking the ice and participating in the action by giving instructions, in words or actions, on what they want in particular. It is also a good way to introduce new moves to the repertoire based on the tastes of the person who is getting the performance.

One of the things that I like most about my boyfriend is his extraordinary ability to surprise me. He can show up with any type of clothing and four random objects and create a story in a half

an hour. For him it is as exciting to live the stories as it is to film them and watch them after. I love when he comes up with something new for us to film.

But, be careful, it isn't about making each movie your "most challenging yet" as much as it is an exercise in creativity. What I mean is, we don't always make love with so much staging and paraphernalia, but sometimes we do forget that there is a camera and props and the two of us go at it: just he and I.

The excitement should not rely completely on staging and chasing stronger experiences and feelings each time. That is a spiral that could end very poorly.

But back to the striptease where a partner has to please the man.

You can give a "professional" touch by covering yourself with a towel as soon as the thong drops and shaking it underneath. You can also use a piece of fabric.

A bonus for the daring? Let the towel drop as you participate with him in the striptease. You can also do it together. Create a choreography and practice. You will need several points of view to be able to edit it together, so you will have to change the camera's position and film multiple actions. You can start your choreography by doing the same things at the same time and then move on to taking clothing off each other.

If you would rather suggest than show, the stripper can be behind beveled glass, a translucent screen, or venetian blinds.

Music to undress to

There are quite a few songs that go well with stripteases. Keep in mind that many songs will work, whether they are rhythmic and sensual or are wild with a frenzied pace.

- "You Sexy Thing," Hot Chocolate
- "Hot Stuff," Donna Summer
- "Hey Sexy Lady," Shaggy
- "I'm a Slave for You," Britney Spears
- "Moving on Up," M People
- "Flashdance... What a Feeling," Irene Cara
- "You Can Leave Your Hat On," Joe Cocker
- "I'm Too Sexy," Right Said Fred
- "Let's Get It On," Marvin Gaye
- "I Like to Move It," Reel 2 Reel
- "Slave to Love," Brian Ferry
- "Dancing with Myself," Billy Idol
- "Blues in the Night," Jimmy Smith
- "Rock and Roll," Gary Glitter (the music from the striptease in *The Full Monty*)
- "For Strippers Only," Sonny Lester and His Orchestra
- "Black on Black," Dalbello
- "Blues to Strip By," David Rose and His Orchestra
- "Bumps and Grinds," Sonny Lester and His Orchestra (made famous by Jayne Mansfield in *The Vegas Story*.)

Music videos

Sexy

One of the most captivating music videos I have ever seen is "Sexy" by French Affair. Get together with a group of friends and find sexy red clothes: short shorts, bikinis, bandeaus, lingerie sets, brocade or sequined fabrics, shirts, boxers, corsets, sheer blouses, and thongs— the most attractive things that you can find. Forget blue and green accessories, makeup, and clothing.

This video will put the Chroma Key function of Adobe Premiere to the test so that in the final edit it has a background with gentle waves and a beautiful sunset.

Empty out a big room and cover the floor and one wall with special blue paper. You can find it in photography stores. If you have to change the camera angle, cover another wall with the paper. It is important that the paper does not crease or wrinkle so that you avoid shadows and that the lighting is consistent. You will need an additional light to illuminate the background.

In editing, substitute the blue backgrounds with the background that you chose. You will be able to recreate incredible environments without leaving your house.

If you need a close-up of someone, cover up the background with the color blue. If someone has blue eyes, film them with a different background, such as a headboard.

The action: the seductress lies in a bed with all white sheets wearing a bikini or panties and bra, but covered in a sheer fabric. This is a long shot. As the camera approaches she sings and moves desperately. This is done in several cuts so that the camera can change angles.

After another cut, a man enters, diving directly toward the camera. If you can't find a pool with a glass wall or a porthole, and you do not have a camera that films underwater, he can be swimming instead. If he is not a good swimmer, he should be coming out of the sea, running athletically toward the camera.

Close-up of the girl, still in bed. She gives a sexy look to the camera.

Then, after another cut, you film close-ups of bodies. Shaking asses, quick flashes of curves, and three-quarter shots of girls dancing. The singer is still in bed or could get up, dressed to kill, moving suggestively, or cut to her leaving the water, tantalizingly dripping wet.

The next series of shots still has our protagonist, now sitting in an antique chair, with an old telephone at her side. Each shot keeps the ocean and the sky in the background. The protagonist gets closer. Next, after another cut, the man appears with red pirates, waving a red flag in the air. We return to inserted shots of stomachs, butts, women's breasts, men's muscular bodies, and more of the protagonist. Behind the dancers, giant speakers appear that you can make with boxes, aluminum foil, and pieces of round black cardboard. Welcome to DIY filmmaking, where anything is possible!

The dancers continue to dance suggestively, each in their own way. And, with attention to detail, the exact moment the singer says, "You are so sexy," the word appears in bright letters

across the dancers' bodies. The letters should be glamorous and not very big.

Sexier still, the lead appears in a soapy bath, lathering herself, as the man is in the shower, letting the water slide across his skin. Shots alternate between the two of them touching the same parts of their bodies.

To spice things up even further, there are more men and women showering and two girls dancing in a way that is "so sexy" (why not?) up against each other.

A classic from *Showgirls:* girls making sexy poses with a stripper's pole. Sometimes the dance can be more vulgar and other times more elegant, but as you

know, that depends on each case, on the moment, or the circumstances.

Finally, after a medium shot of the woman, take a medium shot of the man.

We made a video where the real star was the water. It is unbelievable how many sexy situations can be created with water.

A secret: we found a completely deserted inlet and filmed ourselves making passionate love between the waves and the shore.

A man arrives

To recreate the video for "Ain't It Funny" by Jennifer Lopez (which is very suggestive), you need a few willing friends who like to dance, flirtatious gypsy clothing, and a large open space where you can film undisturbed. You will create a gypsy camp, and it should be filmed in sepia tone to give the video an evocative tone. You will also need to learn some basic dance moves.

There is a very sexy scene in this video where the female lead arrives wearing typical gringa clothing. Some girls completely change her appearance into something much more wild. The would-be gypsy appears, walking down the road wearing a vest, jeans low on her waist, and a knapsack on her back.

The point of view changes a few times to show her walking from different angles; then, in a medium shot, finally, she gets closer to a tent, where an old fortune teller with giant earrings reads her fortune. A crystal ball can provide a lot of atmosphere. So can a stuffed owl. You can recreate the tent with a camping tent that has an awning, or just with an awning.

Commotion

The mystery continues to grow: medium shots of the lead and an extreme close-up of the fortune teller. The fortune teller shows *The Lovers* tarot card, which explains itself.

In this moment, a gypsy rescues her and takes her by the hand. For this role, choose your most mischievous-looking friend. We enter the gypsy camp, where the women are doing the wash. This gives us an opportunity to see them with water falling and fabrics blowing in the wind, wet and dry. This is when her transformation begins. Pay close attention to the accessories: large hoop earrings, think arm bracelets, a cross on a long necklace, and another big necklace. Another detail: all of the gypsies wear high heels with long skirts that reveal a bit of leg when they move, and some gypsies wear corsets with ribbons over their blouses.

There should be a rope tied to two trees as a clothesline that can also be used

to change clothes behind. In Jennifer's case, the transformation is very demure, but in your video you can have your friends undress you and make you over seductively.

The haunting gypsy

There is a break in time and the new gypsy appears from behind the hanging clothes. A close-up reveals the beautiful, form-fitting shawl fabric that hugs her hips. The lead progresses with her new friends close behind.

We now cut to the male roles in the video. We find them doing acrobatics. You can replace acrobatics with *aire flamenco* moves if that is all your friends are capable of. In the last part of this scene a man and woman dance. Then the video really starts.

There is a three-quarter shot of the lead with the other girls at her side. A shot of the male lead shirtless play acting

bullfighting with a boy. It is important that he has a wide belt, beads, and an earring in one ear. Their eyes meet and share seductive, then defiant glances.

The girls join them and dance around him. There are alternating shots of him and her showing off. She sings, shows off her body, and looks at him sensually.

The music changes and her dance changes to a flamenco style. This should be smooth and gentle, and is about carrying the rhythm, showing off your body, raising your arms, and letting the emotion show in your face. Then give four strategic heels and kicks.

Naturally the girls are on one side and the boys on the other. After she shows off, the boys and girls mix and start to dance together. The two leads dance sensually, as if they are sizing each other up, and she leans back as he holds her. The others dance around them. You can think of some choreography with spins to put here.

The exotic environment often works very well because it helps you get more into a character. When we want to film a movie in a different location, we spend a whole afternoon in our roles as if they were who we truly were.

When we saw *Ed Wood* (which we loved) we became fascinated with the character of Vampira and the chiropractor who substituted for Bela Lugosi as a vampire in *Plan 9 from Outer Space*. They were fantastically mysterious and astonishing playing the living dead.

Of course, I also had Brad Pitt and Antonio Banderas in my mind, and I think he had Vampira and Elvira in his.

We spent an afternoon playing our roles. Sometimes we would truly scare each other and other times we would present everyday life of vampires in the style of the Addams Family. Many ideas

came out of this that eventually would go into a script for a fun, sexy, and transgressive story about vampires. Our house was invaded by the ghosts from *Poltergeist,* and the only way we could get rid of them was to find the right ways to make love. In the middle of trying different positions, strange phenomena would occur, each stranger than the next; for example, the bed might turn upside down, until we found the right, vampiric way to make love and get rid of our visitors.

But, without a doubt, the time that we got the deepest into our roles was when I became a prostitute that he had hired, and even pretended that we had met at a bar. Because this turned us both on, we developed this part in a cocktail bar and did not film it, but we did start to film everything that happened once we got home.

I know that there are people who do not like to play characters as much, but it is something that we love and we get so many ideas for our movies from it. Don't let it overwhelm you; if one of you is bored with the same role, save it for the film.

I imagine that, like many of you, we get turned on imagining ourselves with other people. That's why, in one of our movies, I became my brunette twin, and as soon as my sister left the house, I went to seduce her husband. Needless to say, it did not take me very long to seduce him. We got into our roles as if it was our first time.

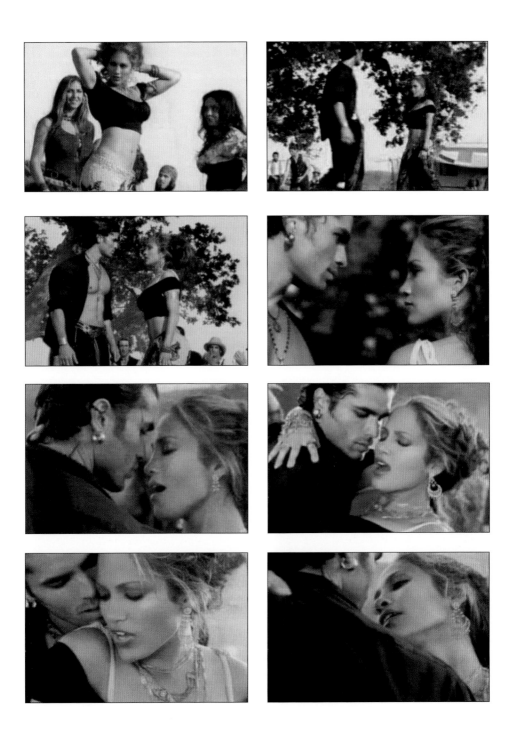

Everything for Your Love

Black and white is ideal for expressing your deepest fantasies. To do this, there is no better inspiration than Madonna, transgressive by nature, and her video for "Justify My Love."

It begins with a dizzy and overacting Madonna walking through a hotel hallway carrying a heavy suitcase. Some of the doors are open and you can see sexual scenes behind them: writhing bodies, fleeting glimpses of breasts and bare male chests, and a dancer with elastic movements.

The male lead appears in this moment exiting one of the rooms in the background. While he approaches her, she falls in an erotic trance and starts to caress herself while making a vicious face. Of course, it is essential that you go all-out with makeup to bring out your eyes, emphasize your lips, and make your skin appear in a pristine gloss.

Madonna is on the ground with her back against the wall in a way that her trench coat is open and you see her sophisticated black lace bra and, as the camera lowers, her garters and stockings to her thighs. She draws him in and they slowly and sensually start to kiss.

New doors open and reveal what is behind them: a man helping a woman put on a lace corset, the woman adjusting her breasts in the corset, a serpentine dancer.

The two are already in the room, she is waiting for him, seated on the bed with her blouse open and bra showing, and he leans into her. There are quick shots of the dancer and then it returns to Madonna, kissing another man, while her original conquest watches lying next to them on the bed.

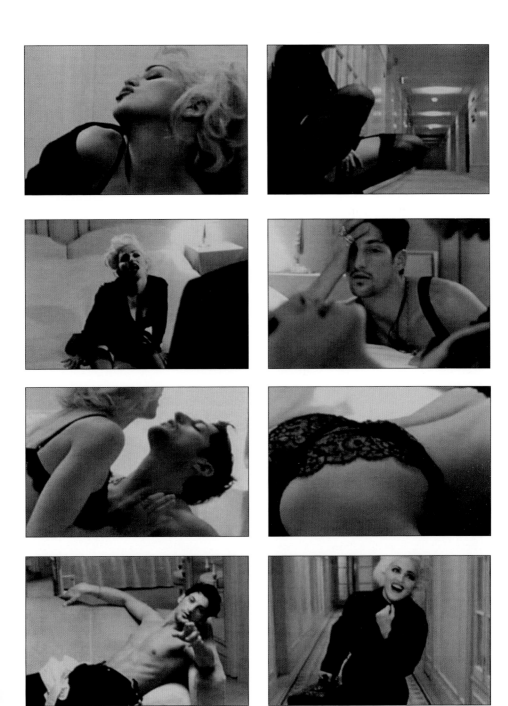

All of your fantasies

Also mixed in is a hot encounter between the two where her skirt is lifted to show her thighs, his shirt is unbuttoned to show his chest, and finally both of them fall together, lost in each other, where you will have to insert images of your own fantasies. As Madonna scandalously demonstrated when she kissed Britney Spears and Christina Aguilera at an awards show, perhaps one of the more exciting images is of two women kissing. Would you dare?

But it also has its counterpart; while she whispers her fantasies and fears, he appears in a slave harness with a woman wearing only suspenders and a leather cap. It is his turn to look at the female lead as the new woman is wildly kissing him.

The scene rises even more when she, with her sexy black lace outfit, sets herself on him. We see how he moves his lips and body over the woman in the seat.

Be courageous and think about your own fantasies. Will you have a threesome? Is she dressed in latex with a whip, walking in front of a cage where he is locked up? Is he tied up with his hands behind his back, knees on the floor, with his chest against his knees, completely defenseless? Is he serving a luxurious dinner completely naked to an elegant woman wearing an evening gown? Is she kissing a transvestite? Are you both dressed like belly dancers? Is she going from man to man? Is he wanted by three or more women and once, and finally, completely ignored by them? Is she a dancer with exaggerated clothing and makeup?

Is he seduced by a woman of enormous size? Is he worshiping and licking her feet? Switching between fantasy and fantasy, or fantasy and reality, is marked

by the sensual, catlike dancer. Playing different roles will help you get your release. She can feel totally like Madonna, and he can feel like the attractive man of her dreams, uninhibited and free.

I realized my fantasy only using a camera and my boyfriend. Well, it was one of my many fantasies. I always thought that porn casting videos were very sexist and only had girls, so I decided to become an experimental director looking for aspiring actors. My boyfriend created a very fun role as a guy who was surprised and downright overwhelmed by the demands of the director. He was a perfect "ingenue" and was "forced" to do all kinds of sexual demonstrations so that I could see if he was right for the role.

In Madonna's video, finally, after all of the fantasies and realities, she leaves the hotel, laughing and running with her heavy briefcase.

To pray

"Like a Prayer" is a classic music video that caused an uproar among religious groups from its haunting opening scene and strong anti-religious content. For now, we can focus on the visuals. Madonna is known for her ability to and talent for continuously reinventing herself.

Like Madonna, both of us try to continuously reinvent ourselves in our sex lives and in our videos. There is nothing worse for a relationship than monotony. For us, sex can be summed up in this sentence: "Always the same, always changing."

Get all of your friends ready to laugh and recreate a place of song and prayer with an area where they can be the gospel choir. You will need crucifixes, candles, pictures of saints, devotional pictures, golden columns, and an altar table with a white tablecloth to recreate the church. Don't worry, you can do marvels with Styrofoam, gold spray paint, and cardboard.

The video starts with Madonna running desperately at sunrise. The scene has very cool tones, except for a fire barrel in the background. Fire offers a lot of atmosphere and can be very exciting, but be aware of your surroundings when you light one. If you have a friend with a spacious yard, you can gather everyone there; not only will you be filming there, but starting a party.

Everyone will wear white, black, or red robes, except for the star, who gets a sexy black dress! The saint wears a red cloak over his robes, which are otherwise an immaculate white.

Madonna runs and falls to the ground, lifts her head, and looks at the camera. You can use a soft, low temperature side light that will bring out details in the hair and illuminate the profile of the star.

Several things happen in quick succession: a huge metal door slams, there is a burning cross, some men are beating Madonna, you see her face as she is on the floor again, and then, a brightly lit

church is shown, and police have the male lead detained.

Finally, Madonna stands before a saint behind bars. To make your saint more credible, you can use silver or gray body makeup, sold at costume shops or carnivals. The male lead has to stay statue-like in a prayer position with a red rose in his hand, stiff and unmoving. Tears run down the saint's face and Madonna, in her subdued black dress, has a look of ecstasy . . .

Play with the effect of the candles and the orange light that they give to the scene. The protagonist lies down on a pew, sits up, raises his arms to the sky . . . all very plastic. She jumps and falls into the arms of the gospel singer, who throws her into the air again.

The holy and devout

Now she is back at the saint's feet, which she kisses piously. There is a mixture here of piety and sexual tension. He kisses her like a child.

Then he walks out the door and she picks up a knife that has fallen to the floor next to the rose. She accidentally cuts her hands and drops of blood appear in the form of stigmata. The camera pans to the congregation gathered on the other side of the stage, as they fall into religious ecstasy.

We return to the scene where she is being assaulted, but now the girl is stabbed with the knife that was next to the rose. Stabbing scenes alternate with scenes of the church. The saint runs to the girl's aid right when the police come and blame him. A disturbing fact: the girl is watching her own attack.

In the next scene the congregation is dancing in front of burning crosses (be careful with fire, you can always improve things later with Chroma Key).

Disheveled, Madonna kneels before the singer who presses her head down, earnestly. She joins the gospel choir and is carried away in their dance, clapping to the rhythm, and the straps of her dress fall to reveal more of her cleavage. Finally, there are steamier scenes as she kisses the saint, who then returns to his part of the chapel. He becomes the boy who tried to rescue her and she goes to visit his jail cell. The most exciting scenes are, without a doubt, the ones that were prohibited, or at least we like to think so. Do it in a public place, especially if you run a chance of getting caught, do it with someone forbidden (a friend, a priest, and that is when it is necessary to build a backstory) or deceive your partner. A secret meeting, quick, lustful, and wild, can be the most exciting.

We shot one of our movies in my boyfriend's office. I made sure to wear very elegant, but sexy clothes, with high heels, and we went at it on his office desk. We act out sex in a forbidden place, with the urgency and passion that is required in those cases, since the threat

that someone can discover us is ultimately real. We don't completely take off our clothes, we simply undress as much as we can. In the chaos I lost a shoe that I had to recover with a question that is common to these scenes, "have you seen my shoe?" Meanwhile we quickly dressed. We spoke only in whispers and, when we were done, after a quick and furtive kiss, and taking care to remember the camera, I left the office normally. It was all an adrenaline rush!

In our videos we have found that recreating typical erotic scenes is very exciting, especially since we not only get to live them, but have them recorded to watch later. It is an amazing feeling to see scenes that you would typically see in erotic films or even porn (more or less porn) acted out by us; it gives them new meaning.

I only care about you

Shakira is the star of the music video, "Que Me Quedes Tú," a video that can test your camera skills. It is a very simple, but striking video that you can make even hotter.

Again, sometimes the ideas that are the most basic visually have the most to say. One time we dressed up as Barbie and Ken. I was dressed in pink like the star of *Legally Blonde* or like Jayne Mansfield. I carried a pink stuffed dog that I wouldn't stop talking to and gave it as many pink kitschy accessories that I could find. I continued to direct my dog, and the gentleman who was my companion. I was inspired by Zsa Zsa Gabor, among others, to play my role and talked like a prissy woman (although my actions were anything but prissy). I

let him take off some of my clothes, but not my hat, my accessories, or my pink bra and panties.

I would direct him with my voice, with a sharper tone, making me dignified and serious and treating him like someone in service. It was very sexy.

Back to the Shakira video. It is all filmed in a hand-held style. To film this way, you have to move with the stealth of a cat or the smoothness of a dancer.

The shots are very dynamic, but not sickeningly so.

Do not use any zoom because it will make the shots shaky and the movements seem larger. Don't hold the camera up by your face, but try to hold it at your waist.

Carrying the camera in your hands can perform many movements that you would normally see with a dolly or a crane. Obviously it will not give you the same quality as those pieces of equipment, but it works very well in videos like these that require spontaneity.

You can also sit in a desk chair with wheels, a shopping cart, or create a

homemade platform that you can use for dollies and tracking shots. You will need someone to push you. Gently too, if you don't want your shots to be dizzying. I know someone who crossed a whole living room, which was very spacious, and hit a cabinet. No comment.

Needless to say, to film this music video you will need a spacious home to turn into a set. Actually, the music video

"Que Me Quedes Tu" is also the story of a transformation. She has to let her hair down elegantly and put on a shirt and jeans after wearing a red scarf strategically arranged to look like a dress.

Her contained, almost formal look is reinforced by the fabric choker that she wears around her neck.

What a surprise! A blurred street, busy with pedestrians, is behind the

singer. The first surprise of the video is that, at one point, the lead moves to the side and we see that the city is actually a fake backdrop. In that moment the wall turns blue and the illusion is broken. A quick glance tells us that we are in a studio where team members are driven crazy by Shakira, who is filming her latest music video.

The next step is to let her hair down, and to remove the handkerchief to reveal a tight tank top and jeans.

She moves in a wild and crazy fashion (this is a great opportunity to move your hair and body, and for the camera to capture all of the woman's body).

And a sexy, priceless detail is that at one point the girl steals a notebook from one of the crew members and writes something in big letters. When she shows it to the camera, it covers her face and you can read, "Dependo de ti" ("I depend on you") as she sings the same thing.

All of the different crew members with microphones, cameras, headsets, and other equipment used in filming are in the background. If your female lead can play the drums, this is an opportunity to show off. If you don't know how, or don't have a drum set, you can improvise with some metal paint cans, or replace it with a scene

of crazy dancing. After another attempt at filming the music video, she runs away.

All of the crew members run behind her carrying clothes that she has to wear, sheet music for her to sing, makeup, and cosmetics . . .

My advice is to shorten the first part and focus more on the meeting of the two lovers, making it much sexier. More than just prudish hugs: a good movie kiss, even more touching, or maybe start to take off some clothes.

Sometimes the most basic solutions work the best. One time we saw the crazy music video for "All the Small Things" by Blink-182, and we borrowed some of the ideas. The result was a very funny video that was also erotic.

Among the scenes that we recreated were the lead dancing in a sexy way wearing underwear, shoes, white socks, and a sailor's hat. We also dressed him very elegantly and had him sing so that you could see that he was gap-toothed.

There was also a sexy dance under a stream of water provided by a hose that was being held by a guy on a ladder, or the man running on the beach in slow motion, dressed as a woman. All of this intermixed with images of us cavorting or dancing sensually. Very sensually.

Naughty children

The most sensual thing is not always the most obvious. Saying this reminds me of a music video that we filmed recently that got us very excited, despite the fact that really, nothing happens. On top of this, it is a very brave cover of a song that could, in principle, seem pretty sappy. The song is "Something Stupid," originally by Nancy and Frank Sinatra. The leads are, of course, Nicole Kidman and Robbie Williams. I have translated the lyrics of this song and you can see them at the end of this book. We film a lot of scenes of love and affection between the two of us, as well as nasty and loving glances to intersperse within the video, and above all, we prepared to film a story of love and passion.

Like Robbie and Nicole, we dressed up for the scenes where we fall in love and think of each other when the other person is singing the song.

We were especially tempted by the part when they were at the bar, as we were looking at each other, entranced, and she starts to sing to the friend at her side. He looks surprised and annoyed and she lowers her head in shame.

Among shots of flirting and suggestive recollection, we also had fun with the exchange of Christmas gifts that we staged nearly identically to the original video: a small handbag that would have as much

of a leading role, and that I delicately took in my hands; the umbrella that he offered me with his mouth as if it were a flower, and I took it in my mouth; the pajamas he would get; the "whip" that I hit him with gently, to his surprise and joy.

In addition to the preparation details, such as looking in the mirror as I gently stroked the bag, or gently testing the flexibility of the whip and giving it one playful bite, we put in our own details: I take off my earrings in front of a mirror with a drop of perfume sliding down my neck: my dress slips to the floor; my silhouette sways gently; his shadow is outlined on the wall while I sit on the bed by his side; a shot of his neck with a drop of sweat sliding down it . . . Yes, sweat during sex is very sexy.

When we finally meet, we changed the light to look like we were in the shadows and we act out the subtle sexual encounter of the video, specifically him gently kissing the bag placed over her pubis, her mouth biting the whip, and the two bodies finding each other, caressing his back, her body arching backward... all of these scenes mixed with the previous scenes: the courtship, the romantic dancing, and the two kissing.

A secret: even though we are inspired by existing videos, when we film our music videos, we never obsess over following them to the letter. They are only a starting point and we have fun improving them or making them our own. Among the songs that we have enjoyed dancing seductively to have been "I'm a Slave 4 U" by Britney Spears, which is a perfect combination of rhythm and sensuality; "Gangsta Lovin" by Alicia Keys, very rhythmic; "Hey Sexy Lady" by Shaggy; or "Crazy in Love" by Beyonce. We don't have any movies for these songs (at the moment), but we play them to dance to, or for ambiance. Who said that sex had to be serious or transcendental?

Dual Fantasies

**Erotic games and role-play...
that's even more daring**

Flames

In your stroll through filmed eroticism, you cannot skip the effect that the fireman who puts out the fire has, or even more, who puts out her own fire.

You can get your burning atmosphere by using a filter that gives the picture an unreal and incandescent glow. Use a gradient filter that is half-colored and half-transparent. These are particularly well-suited for shooting exteriors and can simulate the reddish hue of a large fire. The larger the aperture, the more diffused the separation is.

To simulate the flames around you, you can use tree branches on wooden supports on the floor. Light the branches with a yellow or orange bulb placed on the floor and move them to reproduce the motion of the flames.

You can also record a fire for your background and add it during editing using Chroma Key. If this is not available to you because you cannot edit on your computer, you can project a slide onto a screen or transparent surface behind the subject.

To direct your rescue, you can play with glances and even adopt classic film tricks, such as only illuminating eyes in a dark environment. You can get this effect by putting a box on the bulb so that the light only shines on what you want it to.

The fireman scenario is a perfect situation for fantasies of sex with a stranger. And he really can become a stranger if he takes nothing for granted and becomes his character, even sexually. To play as other people will allow you to take on a new sexual identity. Make the scene even hotter by doing it all without saying a word, or better yet, using only sexy words related to fire: "I'm burning up," "water," or "flames" can be said at key moments.

Play with looks and desire and small touches, like joining hands when the two need to keep distance but still must touch. He has to save her from the fire;, the fire that consumes her.

Fire scenes perfectly frame amorous encounters and give them a magical feel. One time we shot a movie where we continuously alluded to a voyeur watching. We made sure that he knew we were performing for him, saying things like, "Look, she is undressing so that you can see her tits," "Are you excited?" "Yes, now he is very excited; penetrate me to make him jealous," along with other directly obscene or vulgar language.

Incidentally, there are some books written about sexual fantasies, both very interesting, and written by women (both skilled authors): *In Your Wildest Dreams* by Lisa Sussman, and "My Secret Garden" by Nancy Friday.

Kiss each other passionately, but keep something in mind: that your audience can see you. You can achieve this if you use your tongues in a kiss without using your lips, and slightly turn toward the camera. Or you can change the side that you kiss on, so that you can both be seen. If you kiss passionately, also turn partially toward the camera. Some advice: your kissing should be silent because it will be deafening on the sound track and you can add it in during editing. Another trick is to make the shot a close-up and give small, juicy kisses. Make sure your mouths are seen in action, combined with bigger kisses.

"Typical" erotic situations

Don't forget to reenact classic erotic pairings such as:

• Plumber/Housewife, where she lets him see her panties when he is leaning down to look at the leak; she touches him as he passes, her breasts rest against his back as she looks to see what he is doing, or as she holds the door open to let him in, her arm gently falls and her hand accidentally grazes his genitals.

You can explore new perspectives, otherwise inaccessible, using mirrors on your floor or ceiling. Note that the reflected image is a reverse image, so do not forget to flip it in editing.

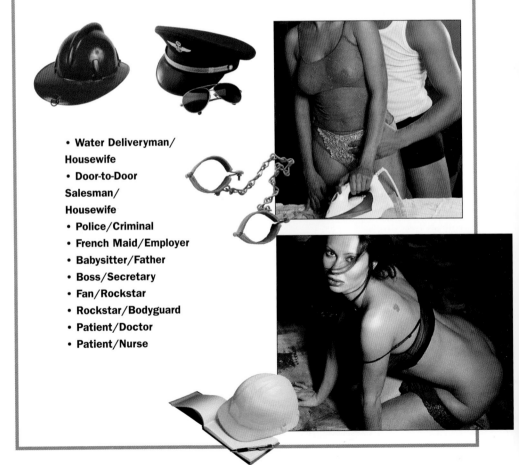

• **Water Deliveryman/ Housewife**
• **Door-to-Door Salesman/ Housewife**
• **Police/Criminal**
• **French Maid/Employer**
• **Babysitter/Father**
• **Boss/Secretary**
• **Fan/Rockstar**
• **Rockstar/Bodyguard**
• **Patient/Doctor**
• **Patient/Nurse**

Sex fantasy: "I'm your slave"

Now that we are doing something a little more daring, we always insist that you set your limits and stop as soon as one of you is not ready to continue. You can recreate a Gothic scene or a torture chamber with candles. Choose elegant candles, long and thin, if you want a refined scenario, and gruesome candles if you want a "nightmare" scenario. Candelabras can give an ominous touch to the scene.

Place candles at several levels to surround the scene. Use props like shackles, a whip, or another object from the world of sadomasochism. Leave them in full view. As a complement you can wear masks, eye masks, and capes. The lover can go dressed in leather and he, her slave, half-naked with a black leather dog collar, a thong, and a leather harness. You can also put a giant post in the scene that will serve to tie up the victim.

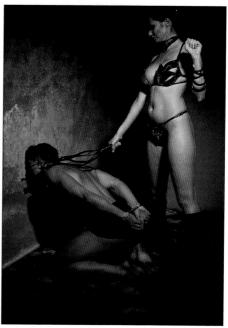

You can use standard lighting and put some candles to one side to give it a special touch. Complement the candles with yellow bulbs to accentuate the warm lighting.

Place candles between the actors and the light, which must come from below. In the event that there is too much light, you can make the image darker in post-production. You can get interesting effects with the candles if you use a star filter.

To get shots of just candles, to create an ominous atmosphere, light them from one side.

For your setting, you can use colors like red, black, purple, or yellow. The last

two, combined, create an atmosphere that is as captivating as it is threatening. There are also excellent red and black and purple and black combinations.

A good starting point for your video is for your man to start moving and, as the camera pulls in, it is revealed that he is chained. Next, the woman holding the chain appears and begins to torture him. The woman should demonstrate at all times that she dominates the situation and moves her partner at her will as if he were a doll. Find postures that emphasize his submission, like kneeling, leaning forward to support his chest with his legs, and with your feet, wearing exquisite heels, on his neck or back. Or he could be hugging your calves.

Reward or punishment?

Alternate "punishments" with "rewards." Slide your tongue slowly across his chest so that he can see you and then make him get on his back, put his ass in the air, and hit it with a paddle.

Kiss him and then twist a nipple in a way that looks good. Rub yourself against him, touch him, and then back off to torment him a bit more.

Make him lie face up on a mattress or cot that is covered in red or black satin. Maybe it is time to move on to more refined torture, or dedicate yourself to wax, an erotic sadomasochist game widespread even among couples who do not belong to that world. It is about melting hot wax on your skin . . .

If you decide to do this, use parafin wax because it burns at a lower temperature. The waxes have to be light colors (metalized candles melt at too high a temperature). Use a long candle and befo-re you begin, cut a small incision on the end of the candle so that the wax will fall.

Hold the candle about 8 to 12 inches away so that it isn't too hot, and let it drip slowly. Try to give the camera a good view of what is happening. It would also be useful to film his face as the wax falls on his body. Pamper him after removing the wax.

For the shots of him lying down and you on your knees leaning over him, put the camera at a good angle in a tripod. Don't forget to change the angle to add new points of view of your bodies. Also take an angled shot of the lover to show her power and a downward-facing angle of the man to show his weakness.

When you finish the session, remove the wax with a plastic scraper. It will be easier to remove if you apply ice to it. Spread moisturizer over the necessary areas. He shouldn't suffer that much!

In the same line of domination-submission, my friend was preparing a surprise party for her boyfriend. He had barely entered the house when she put a black blindfold over his eyes and led him to a spacious room that had been completely emptied, save for a number of colored candles. She called several friends there and they undressed so that he could not tell if there was just one person or more. He was caressed timidly, intimately, strongly or gently, tickling or playful, precisely . . .

My friend assured him that one of her assistants was filming everything. Then they withdrew into the room where they had put the bed, she pulled him on her, put the camera in the tripod, lit a few more candles for ambiance, and made the whole thing terribly exciting. She never told me what happened with the guests; I imagine that they left of their own will or slowly joined the party in the room.

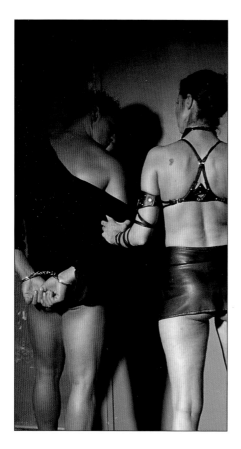

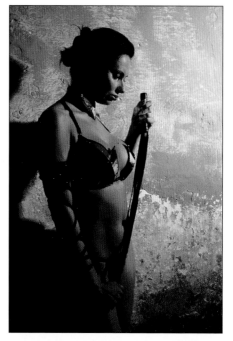

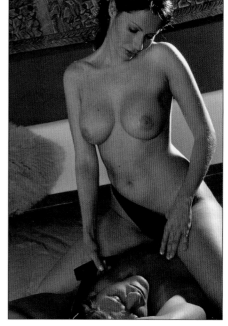

A friend of mine who is more demure—to a certain point—made a similar scene, but did not call anyone. She managed to multiply herself so that he thought he had more hands on his body. Using gloves of different textures, some imitating hands larger than her own, she used fabrics and touched him from angles that made him believe there were more people in the room. Music was playing to drown the noise of her movements. She would occasionally whisper, "Trust me, another woman is coming, she will not hurt you, she will only please you." Evidently the result was even better.

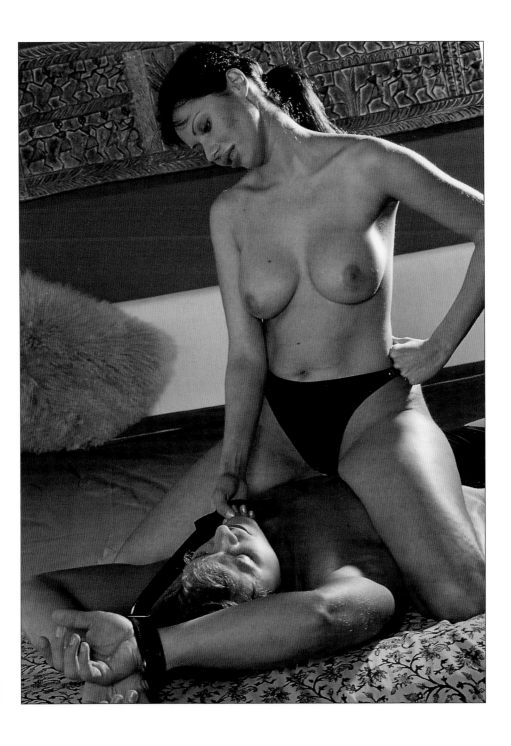

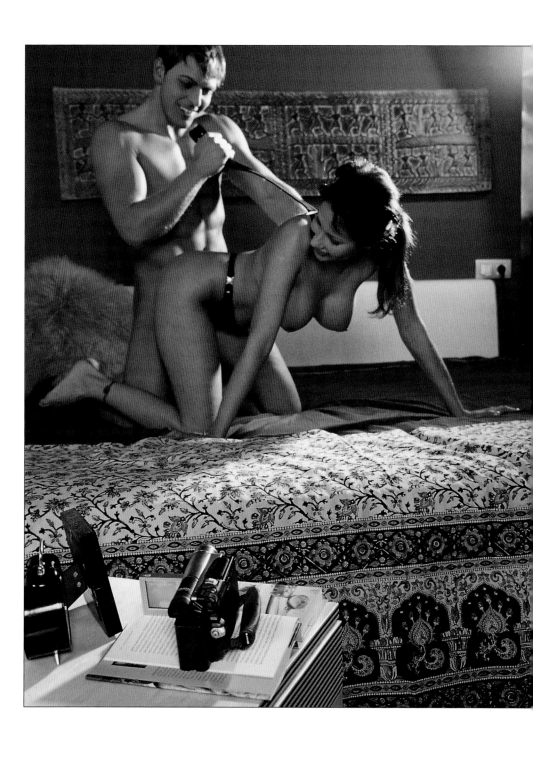

History of the O

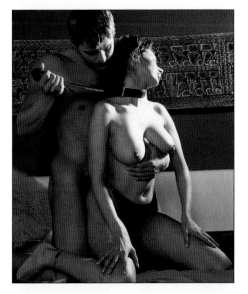

A good way to start this video is for him to blindfold her in one room and lead her into another. On the way, stop to caress her gently from behind: her hair, her face, her neck, her breasts . . . She can wear a light satin nightgown so that you can see her nipples get hard or a provocative evening dress to contrast sophistication with the events that are unfolding. Each stop is a chance to change the camera position so that when it comes time to edit you have views from every angle.

Have a good conversation before you start this fantasy so that you know your limits. To get even more out of the excitement of the situation she should not know exactly what is going to happen, although she will get a general sense beforehand, as there will be whipping, and for some time, she will have to obey. It is a test of love and confidence recommended for intimate partners. For both of you: maybe he is preparing for when you will obey his touch.

He might ask you to undress, to display yourself, to touch yourself, to dance for him, to get into certain positions, to fake an orgasm, to wail, to say obscenities, to humble yourself in a certain position. Everything has to happen with tenderness; it isn't worth it to take revenge for the "wrongs" of a past discussion.

My boyfriend surprised me once by completely changing the script. First I was submitted to a traditional phrase:

– "Today, I am your master and you are my slave."

I nodded.

– "Do you understand what that means?"

– "Yes," I said

– "No. You must answer me 'yes, sir'"

– "Yes, sir," I say again.

–"Today you will please me however I ask you to."

–"Yes, sir"

–"Undress in front of me slowly."

I did it, but I left my bra and panties on.

–"No, everything."

–"Good, continue. Now lie down in the hallway and support each leg against the wall," he said as he took a clamp and a blanket to lie down over me.

–"Close your eyes," he ordered again. I still had time to see how he was filming me, opening and closing my eyes. He put the camera on a tripod so that my body could be seen from my shoulder.

When I thought he was going to punish me somehow, penetrate me, or satisfy himself in some way, I could feel his tongue on my clitoris. The uncertainty made me very aroused. When he realized that I was going to cum he ordered me to stop, "No, not yet." He moved the camera, stimulated me with his fingers, and put a clamp on my nipple. The pain was both torturous and exciting.

He returned to oral sex. Again, I felt like I was going to burst and he stopped. He put another clamp on my nipple and the sensations were delicious. He changed the camera's position and pointed it directly at my genitals. He slipped his greedy fingers in.

He got back to work with his mouth and whispered to me:

–"Now."

The orgasm was unstoppable.

He pulled his pants and underwear down, stood over me, and started to masturbate. He made me count from ten to zero. When I got to zero he came.

Spanking?

There are different positions and kinds of spanking. Some, without being totally harmless, are considered "accep-

table" within these kinds of games. As always, it is important to know your partner well and agree before you start.

As for the positions:

• **Bent over**. With your legs straight and waist bent over, grab your ankles with your hands. If you are inflexible, you can grab your knees. Your back should be arched.

• **On a table**. Support your chest on a table.

• **On a stool**. The person taking the punishment is kneeling on a padded stool or chair. Their feet and arms should be dangling or on the back of the chair. Their back should be arched.

• **On the bed**. The person taking the spanking is lying facedown on the bed, with several pillows under their stomach so that their butt is lifted into the air.

After it is done, turn the whole process into a ceremony. After spanking he can surprise her with something very, very, very nice.

Needless to say, there are people who do not like this kind of game. It is a sensitive area where there are more risks (almost always more psychological than physical), that everyone can and should choose. Avoid it if you do not enjoy it.

Some typical characters:

• **Naughty Schoolgirl**. The traditional attire is a pleated miniskirt, wool knee-high socks, loafers, and a shirt. Lie on your knees, facedown, lift up her skirt and pull down her panties to reveal her bare ass, and give her open hand slaps.

• **Standing Submissive**. Tie them with a handkerchief or a leather strap to a piece of furniture so that they are facing away from the camera. Stand to the side so that her reactions can be seen.

• **Submitted Slave**. You can tie her to the bed so that she is lying on her side with her butt exposed. Use rope to tie

her ankles, another to tie her thighs, and a third to tie her arms to her body.

As important as the spanking itself are the things that proceed it. To make the situation, and your movies, more exciting, talk to her as you prepare and as you spank her, and let her know why she is being punished. The two of you should write the reasons why. Agree on the force of the spanking; start lightly and slowly increase the intensity. You can also use a Ping-Pong paddle.

The basis for a good spanking posture is that the butt is well exposed and the spanker has room to move their arm easily, allowing them to dominate the submissive.

Remember, the two roles can easily switch.

Another idea is to show a succession of shots of the submissive in different forms and different backgrounds, like snow.

One Thousand and One Nights

Often, it's the little details that make the difference. You can get impressive effects in your videos by filming time-lapse videos that show, for example, the passing of clouds, the opening of a rose, the rising tide, the movement of the moon in the sky, a sunset, the hands of a watch, cars on the street . . .

Super 8 cameras have a button that lets you shoot a frame every few seconds or minutes. The result is that a record lasting a few hours is reduced to seconds, and everything seems to move rapidly. Other camera models are less accurate, but can also record frames and get the desired effect.

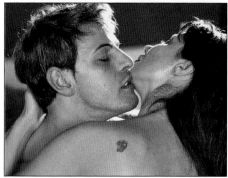

If your camera does not have this option, you can record the whole process on one or more tapes and upload the video to your computer for editing. You will have to do it in parts because there is a capture limit. In any case, whatever method you use you will need a good tripod, a charged battery, and at least two spare batteries just in case (to avoid power failures). Alternate images that you get this way with images from your story, or meeting, or use them, as is the case with the clouds hurrying by, with Chroma Key to give a magical atmosphere to your videos.

Use this background with costumes: she should look like a concubine, and he should look like a proud sultan wearing a turban with shimmering fabric. Hang several large mirrors to multiply your image.

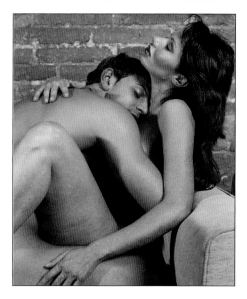

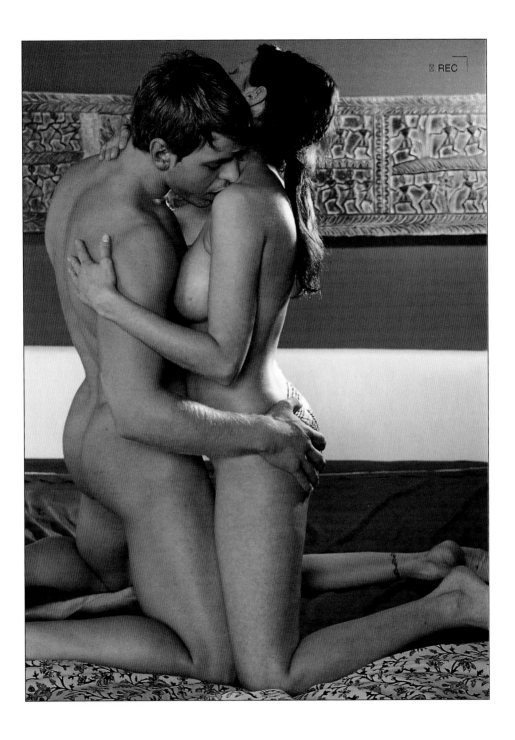

You can start with words; maybe she can narrate or read an erotic story. There are many to choose from: *Fanny Hill* by John Cleland, *Pauline the Prima Donna* by Wilhelmine Schröeder Devrient, *Delta of Venus* by Anaïs Nin...

You have two options: you can make the atmosphere heat up slowly and inexorably, show it in your movie and little by little show how she seduces with words and he seduces with his touch. Or you can film a parallel story that dramatizes her telling of the story, and when she is done they seduce each other.

Subtlety

Smoothly coat the story with kisses, kisses, and suggestive, soft kisses, with the camera watching and taking pleasure in the lovers. Kisses on the belly, on the shoulders, on the neck, on the inside of the thighs, on the inner side of the ankles, on the arms, and on the feet. Affectionate kisses, wet kisses, kissing with the tongue, which then tours the rest of the body.

This is when you ask what she wants, especially if she is shy. He will swear obedience whenever she fully expresses her desires. To stimulate you visually and sensually, use clothes and objects with all kinds of smooth textures: powder puffs, feathers, brushes, silk scarves, and her own clothes as you strip her.

For me, our most erotic video (notice, I didn't say pornographic) is one where nothing happens. We tried to touch each other with a veil moving in the wind or in a strategically placed fan. We both wore white underwear. I wore a black crochet necklace to add a touch of color and a silver chain around my waist. He moved the fabric and it ended up on me. He kissed

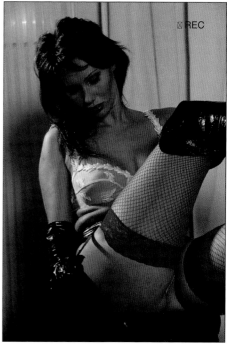

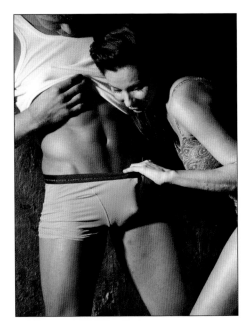

me on the neck through the fabric, gently, and moved his hand toward me. He didn't touch me, only put his hand on the fabric that covered me. We caressed each other through the fabric and freed ourselves, as if pleasure were born in that moment. From here, I felt everything, my long red nails sliding down his stomach, his finger zig-zagging on my back, the fabric turning into a shawl, passing between us, a strap falling . . .

Your exotic fantasy can also appeal to your sense of taste: you can serve delicate desserts on your partner like whipped cream or chocolate syrup that you passionately lick off of your partner as if they were ice cream. Use strawberry syrup and let it dribble down your skin. Film drops of syrup of another color sliding down your back and butt.

These are only ideas; you must take all of these suggestions and create your own script for what might be a sensual evening in the thousand and one nights. Just one more recommendation: pleasure is permitted.

To anyone reading this: when the mood gets heated, surprise your partner with a box that has a sex toy for one or both of you. If you are not very daring, it can be jewelry for your nipples, clamps for your nipples, a cock ring, or edible panties.

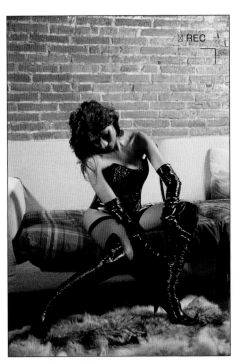

Beauty and the beast

She appears before him, a "femme fatale" or the woman of his dreams. You can give the details of her dress as she puts on her stockings, she adjusts her garter, her dress slides on her body, the touch of eye shadow is put on her eyelids, a finger slides gloss across her lips. All very subtly, there must be a great contrast between the delicate beauty and the beast.

He may appear as a dangerous man, dressed as an orangutan (if you have a gorilla suit or can rent one at a decent price), or dressed as a cruel pirate such as Johnny Depp in *Pirates of the Caribbean*. Decorate your room as if it were a hut. You can try to get palm leaves to put on the wall or go to the store to get some kind of reed decoration to give it the appearance of nature.

She takes the camera while he evolves like a crazy jungle man or runaway ape or whatever other wild beast inspires you. He will have to stage a wild striptease.

This story will gain a lot in editing. To accelerate the pace of montage, take shots that are shorter each time. You can increase the tension by putting two or three shots in the same sequence.

Present her in various innocent poses. The key here is that she is passive and he directs the action at all times. He undresses her and she lets him do it.

You can prepare the clothes so that the swipe of a claw will undress her. Combine tenderness with a wild quality. Maybe he offers her a rose or rose petals.

Balancing softness and strength

He should have a brilliant, energetic, and virile dance for her. She, half-naked, can be placed on the ground or a bed, depending on how the scene is set, sitting on her heels with her back straight. This pose highlights the female form and is very flattering.

Begin to make it more erotic when he takes her head (gently, but firmly) and pulls her hair. She withdraws a bit out of fright, and he kisses her hand delicately.

Now, a close-up of both of their heads, with special attention on their lips, a luscious kiss, slow and allowing both of their mouths to move and tongues to move passionately looking for the other.

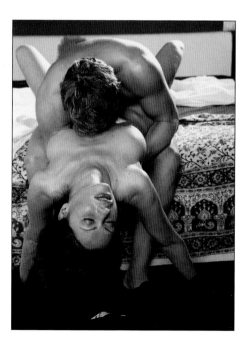

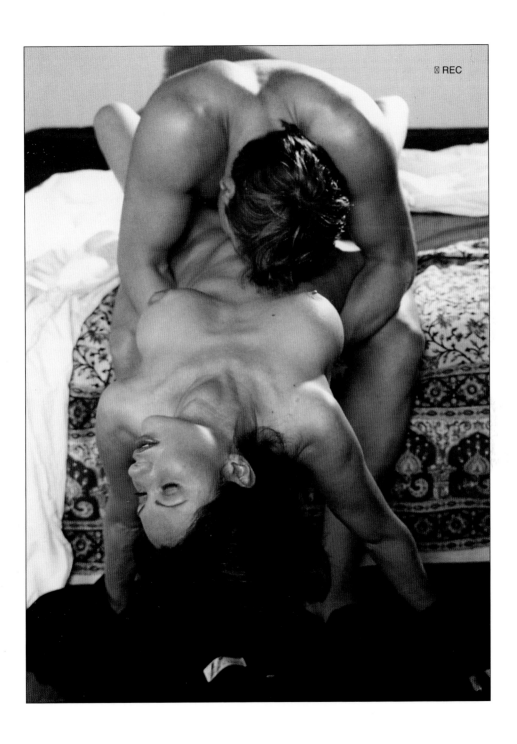

His roughness should contrast with her sweetness. She can rub his skin with a rose after he offers it to her. In your videos, don't forget to play with the props; their uses can be varied—to reveal, to cover, to insinuate, to caress.

This video is usually wilder during its first daring parts. Making erotic videos can be addictive; once you start to like the camera, you'll want to see more and more of it, and put yourself in even more explicit situations. Let yourselves turn filming into a steamy sexual encounter. If you have any kinds of shame or any qualms, think about these videos, as they might tell you otherwise. Because they are only for personal consumption, they will serve as a reminder of your passion.

A useful trick: it is very likely that you will be overtaken by passion and your takes will get out of hand, but you can repeat a scene on a different day to film other angles and positions. Remember to record your faces in key moments to reflect how you feel. We tend to repeat scenes and shots as many times as it takes because we are perfectionists and because we like to explore our situations to the limit. This way we also come up with new ideas and different points of view.

To be sure that we are not breaking continuity, we take a few snapshots of ourselves, our state of dress or undress for the occasion, or our stage of wild fantasy. This is how we recreate everything to the smallest detail the next time we shoot.

"Girls, to the salon"

Among the most common and successful roles is that of the prostitute and her client or the gigolo and his client. With a slight twist to your attitude, you can be different.

Are there some sexy images? In these cases, money usually appears as an icon: a pile of bills delicately placed on her bare back, a pile of bills that slowly cascade on his body, a shot of a female leg in a garter and stockings and a hand taking money, a male thong that a woman slips money into, a man putting money into a woman's cleavage, a woman who asks for more before doing anything "extra . . ."

Let your characterizations of sex professionals be believable. If he hires her services, he can wear a modern, impressive suit with a bit of dissonance that makes him seem vulgar. She can be a sophisticated woman like a little vixen with somewhat vulgar makeup. Create a character with all of the consequences for the occasion.

You can also use a Marilyn Monroe–type look, not directly using her image, because the girl may not seem like her, but use her seductive tricks like long and elaborately painted eyelashes (if you want long and curly eyelashes, use *Illusionist* from Estée Lauder, and if you want a false eyelash look, use *Cil Architecte* from L'Oréal).

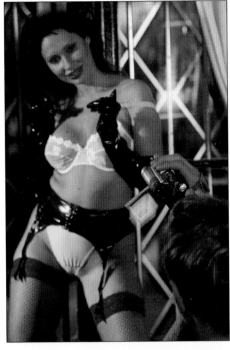

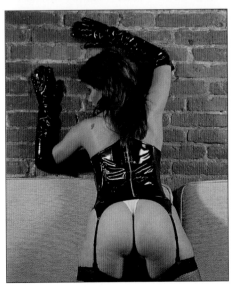

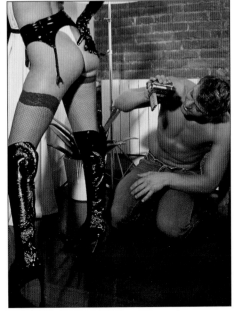

What else can we borrow from Marilyn? Her sensual contours in *Some Like It Hot* and wild flirting, the scene with the skirt and the air vent in *The Seven Year Itch,* and, above all, the image of a sexy and glamorous doll dressed in a pink evening dress with long satin gloves singing, "Diamonds Are a Girl's Best Friend" in *Gentlemen Prefer Blondes.*

More than just sex appeal, the collective memory brings us Julia Roberts's character in *Pretty Woman*: tall leather boots, a miniskirt, a tight top, and a straight blonde wig. A wig is a great way to feel different: before filming, familiarize yourself with your new image and adopt new gestures for it. We can also borrow the crazy image of *Irma la Douce.*

We have recently begun to recreate scenes from movies with more sparkling dialogue. You know the kind: "Is that a gun in your pocket or are you happy to see me?" I always thought that classic Hollywood films left out parts of sex. Where it is well over by the time they kiss, in modern movies there would be a steamy sex scene between lovers.

We wanted to experience it all, add missing sex scenes, and recreate, warts and all, some of the higher voltage scenes in cinema such as *The Body Double, The Postman Always Rings Twice,* or *The Night Porter.* It is very exciting and fun to recreate them, and even though they are classics in the genre, our versions are much bolder.

What is a striking way to begin a movie inspired by prostitution? Offer the client an assortment of guys or girls. I'm sure that you will love exploring both roles in this fantasy. You can each be the sex *professional* who presents themselves in a little dance, create a fantasy where you get a spotlight when it is your turn, or where you explain all of your methods of arousal. Or, perhaps, a voice-over tells the story of each person: "Educated in the harem of a sultan, he was the only one fortunate enough to escape emasculation." Secretly he learned from the favorites, who were bored and dissatisfied, the tricks to pleasing a woman, including the famous, "Venus Butterfly." There are many men who agree that the best part of paid sex is when the women offer themselves and they get to choose.

To get the help of your friend or friends, you have several options:

- Tell them the truth and do not show them the video.
- Tell them the truth and show them the video.
- Tell them it is for a music video and record an alternative video for them to see so they stay happy.

We can also approach the world of professional dancers the same way. They also seduce their customer with a spectacular lap dance (watch *Showgirls* with Elizabeth Berkley). The rules, in the words of the lead, are, "You can't touch me, but I can touch you."

What type of sex worker would you like to play? Decide that first. What services do you offer? What are your limits? Julia Roberts's character, for example, would not kiss on the mouth. Will it be a prostitute or a gigolo going to work, or exploring the human side of their customers?

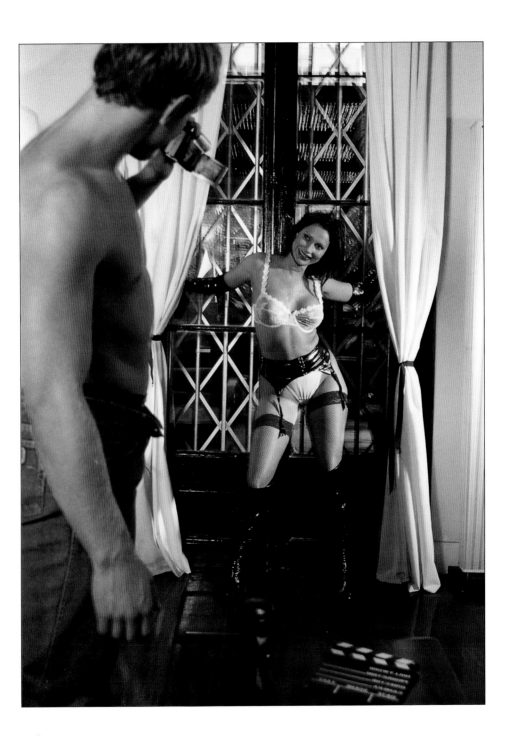

"Boys, to the (beauty) salon"

A beauty session with a full massage offers a full view of the body as it is worshiped and also shows some interesting parts of the body. It is a perfect way to show off physical strong points.

Have no shame: The male lead in the beauty session should know their partner's body and all their curves, as well as what they like. Keep in mind that you will have a few odd angles the first time that you shoot this type of video, especially in hotter parts. You will slowly become accustomed to it and will be able to identify your best sides.

Your beauty session will begin in a different way—instead of undressing, the masseuse will undress them as much as necessary and take off more clothing only when needed. Also, the masseuse will take off some of their clothes when it is needed.

You can film the transformation of one of the two of you, including massage, a body shave with a lot of foam (no wax, please), shaving for him, applying body creams, makeup . . . You can make the script more complex where the beauty treatment enters the realm of fantasy, or a basic script that ends the massage with an intimate surprise.

Massage all of your partner's body, including sensual areas such as the soles of feet, fingers and toes, the back of the knee and, as the tension builds, the inner thighs and genitals.

Then it is time for kissing. Whoever is getting the massage will have to stay completely passive, while the masseuse kisses edible oil on their body, and quiets the surprised protests of the client.

You can stimulate your partner even more and get an exciting visual result with a duckbill technique. The masseuse puts a hand in the shape of a duckbill over their partner's penis or clitoris. Next they pour massage oils on their fingers and watch the oils drip.

You can extend your treatment to the whole body and even determine that a body-on-body massage is necessary for the desired effect.

Be careful with the length of the massage; a long massage can even bore you.

Qualifying with light

If you introduce penetration in a scene, but you don't want it to be too explicit, then I would recommend the following if it comes as a natural extension of the scene. You can play with the light or camera effects such as:

Use one light to the side of the scene that produces dark tones and leaves the figures in the shadows. It is a way to add mystery and accentuate the shapes of the bodies.

If you turn two lights toward a white background, figures will be reduced to silhouettes. You can also use a filter to break down the shot into several identical shots so that your end result is more abstract.

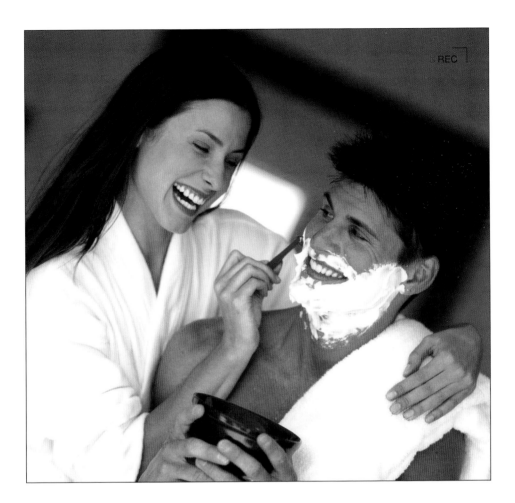

Intimate massages

When the session becomes "complicated," the masseuse can let their client know in a professional manner, through a relaxing deep massage.

To give your massage a better presentation, you can do one of the following moves; remember, they should be showy.

The metronome. Pass his penis from one hand to another in a delicate but firm motion. If he is not erect, he will be soon.

Hand over hand. Move one hand from the base to the tip of the penis; when the first hand reaches the tip, the other hand will do the same thing.

Total massage. Spread her labia with your fingers slowly and gently caressing the area. Insert your index finger into her vagina two or three times and moisten the clitoris with it.

Erotic circles. Make several circles around her clitoris from one side to the other. Then move it back and forth.

Creating a fantasy

Invoke on a challenge: one of you can suggest a topic and the other gets everything needed to recreate it (costumes, scenery, props, makeup, and script) in half an hour.

You can use some of the fantasies that have been previously mentioned, or other new fantasies that you think of; your first time together (including, if you can, the clothes that you wore); virgins making love for the first time; Little Red Riding Hood and the Big Bad Wolf; vampires; over-the-top drag queens; Pygmalion and his creation; a pair of actors in an erotic film or porn, depending on their performance; naked classical dancers; a silent film with exaggerated gestures and kisses, or even portray the villain that ties his victim to the train tracks. Even if one of you tied the other to a tree, you would not exactly be able to just get up and leave.

You can also create a fantasy between the two of you and include an erotic tango, meringue, salsa, or something sensual out of *Dirty Dancing*, and make love while you are dancing. It is about keeping the pace and rhythm and filling the room with erotic gestures, touches, and clothes that fall over the course of the dance.

One way to make the video come out better is if you are near a window that light is coming through or you have some source of light pointing at you, you can reduce the contrast so that more detail comes out in your face. The most basic and economic use of a white reflector is to fill in shadows and soften the picture. A Styrofoam panel across from the light can be just as effective. The advantage is that the light reflects at the same tempe-

rature as the rest of the lighting in the scene. You can use this trick whenever you want to soften your faces.

In your videos, try not to neglect the details of the touch: his hands on her breasts, gently squeezing and stroking them; his hands sliding down her hips and ass (play with the difference between her innocent body and his "tough" hands). The same goes the other way as she subtly or firmly caresses his erogenous zones.

Assembly tricks

"Now I have a close up. Let me show what he sees. Let's assume he saw a woman holding a baby in her arms. Now we cut back to his reaction to what he sees, and he smiles. Now what is he as a character? He is a kindly man. He is sympathetic. Now let's take the middle piece of film away, the woman with the child, but leave his two pieces of film as they were. Now we'll put in a piece of film of a girl in a bikini. He looks—girl in a bikini—he smiles. What is he now? A dirty old man." (Alfred Hitchcock)

Assembly must not only be consistent with what is being said, but it must also have a rhythm and a pace that is

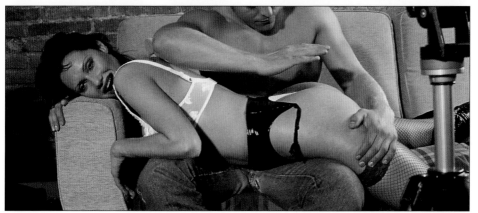

appropriate to the action. The assembly of a party with a lot of people should be more dynamic than a peaceful meeting between two people, where their reactions are more important.

A good way to decide the length of a scene where there are only visuals, and no dialogue, is to watch as if you were an audience member, and decide when you have seen everything. You can use these standard durations as a guide:

• A long shot of a new scene may need ten seconds.

• A less detailed establishing shot of the setting should last about seven seconds.

• A cut to a detail in the same scene only needs between five and seven seconds unless there is movement.

• The duration of close-ups of people depends on the action, but for a viewer to register the expression on an actor's face it should be at least three seconds.

• When panning and zooming, keep the first and last images for at least three seconds.

• Never cut in the middle of movement, for example, partially through panning or zooming.

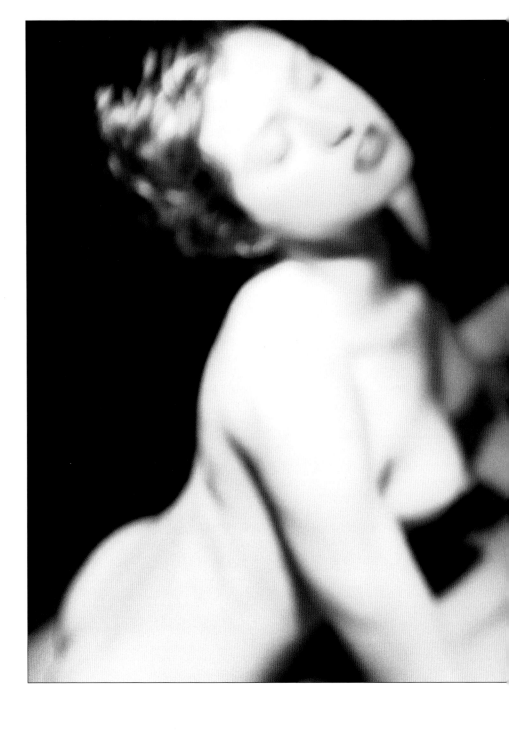

Fiendish Games

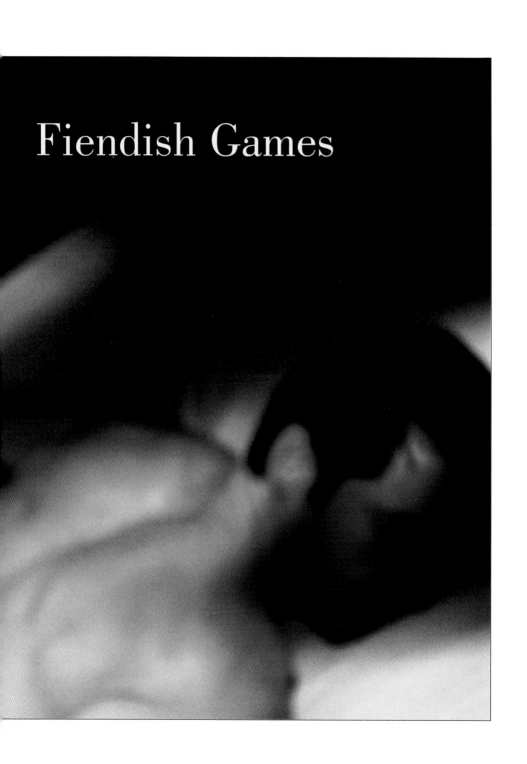

Seductive poses

For him

• Lying facedown in bed with a sheet covering part of his body. Or the same thing without the sheet. His head should be turned toward the opposite end of the bed with a leg flexed.

• Standing in a position that shows off strength, for example, holding her.

• Standing with his back to the window so that his silhouette is displayed. Show him in a foreshortened perspective so that his silhouette will take on new volumes.

• Lying on his back in bed, half upright, supported by a pillow, with one leg bent.

• Lie on his side next to the camera.

• Waiting for her shirtless or naked in the doorway.

• Sitting naked, relaxed, with fabric subtly hinting at his crotch, but coquettishly covering everything else.

For her

• Kneeling on a chair with her hands resting on the arms of the chair. The camera should be in a foreshortened perspective, not directly behind her.

• Standing with her back toward the camera, and hands resting on her lower back. If she slightly turns her body, you can see the outline of a breast.

• On her knees, from behind, with her back straight. A variant is to place her hands on her ass.

• From the front, naked, but with

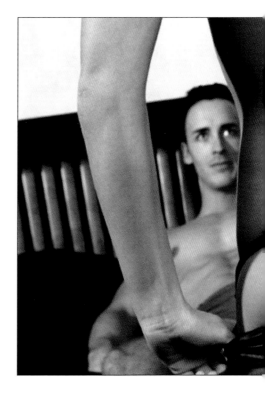

props to cover certain parts of her. Use sunflowers, a big beach ball, or mallets that can also be used to develop new moves. How do you film an artist on trial?

• Crawling on bed facing the camera with her butt raised in the air.

Point of view

Come up with your own ideas to show your partner. Point of view is especially important in shots where the two of you are making out. Porn usually shows the view of the man, or worse, shows the scenes according to male tastes and pays little attention to what women want to see because it is directed toward a male market.

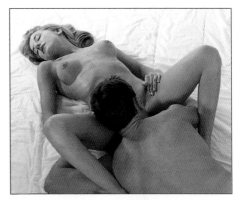

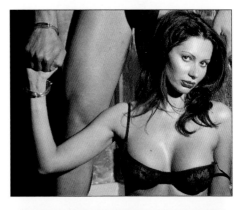

This can be easily fixed in your videos: let her decide on the details and the camera placement.

You can also switch between points of view. During oral sex, for example, when he is standing you can position the camera so that you see it from below. This way it will show her face from the side and his body as the primary motif (feminine point of view). Also offer the male point of view, that is to say, with the camera over his shoulder, so that he can see her face and everything that she is doing.

If the woman is receiving oral sex, her point of view would be to see his face and his actions from above, as she would in real life. This is all very personal and private, but it is normal in your movies to see your bodies perfectly. The best way to do this is to alternate points of view.

Sex Positions I

Always remember where you have decided to draw the line. If at this point you would like to go further, here are some sex positions that can look great on film. Also, you can make some positions more attractive-looking with a few small changes. For example, in doggy style, filmed from the side, it will be sexier if she wears fancy shoes and bends one leg so that her foot is in the air and in contrast with his leg muscles. Pay attention to the breasts in this position: smaller ones can seem tiny and pointed and larger breasts can appear fallen and swaying.

You can fix this by wearing a bra or a corset with the top removed, so that you can still see her breasts, but they will be supported from below. He can also hold her breasts in shots filmed in this position. This position can only be filmed well when she is facing the camera with the right support.

If she is looking at the camera, the result will definitely be more arousing, which some porn or erotic filmmakers have realized. If you film the next from the side, she should turn her head at some point to meet his gaze.

To make your manhood look bigger, the trick is to situate her ass closer to the camera. The best position to show a woman's breasts is for her to be lying on her back. This position is not very good for small breasts because it can make a woman look flat-chested.

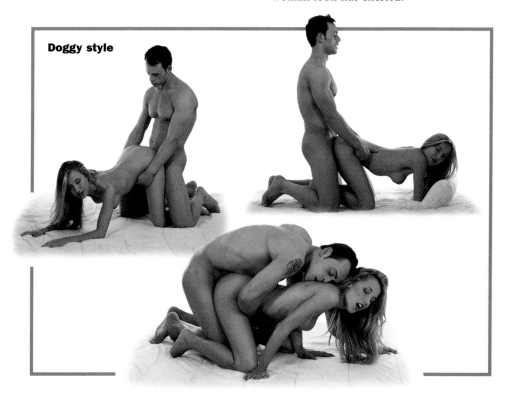

Doggy style

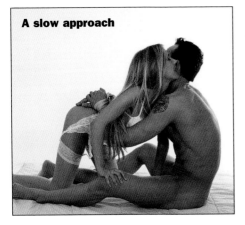

A slow approach

Also make sure to keep the thrusts slow. In the same missionary position, he can lift her legs up slowly so that we can see her more clearly.

An excellent position to show you both is with him kneeling on the bed, with his legs open, her legs also open, thighs resting on his legs, and feet resting on the bed. He can balance by leaning back and supporting himself with his arm. This way, enough space will be created between your bodies so that you can see everything well.

In this position it is important to leave space between your bodies so that you can see them properly and you don't appear as one amorphous blob. This means that if you film in the missionary position he should support himself with his arms so that he doesn't crush the woman.

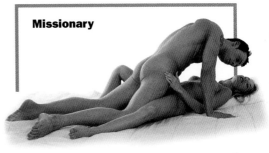

Missionary

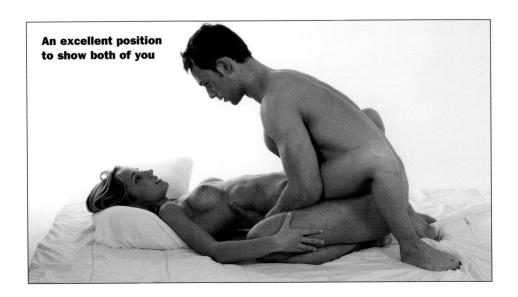

An excellent position to show both of you

Important Advice

Stay aware of your posture. In upright positions, imagine a string pulling the top of your head, keeping your back straight and your shoulders back. Arch your back slightly; this will raise your chest and flatten your stomach. A slightly curved back is also very good for positions where the woman is on top, or on all fours, because it makes her look curvier and accentuates the narrowness of her waist.

If you exaggerate your movements a little (or a lot), you will best capture what you are doing in each moment. For example, penetration will be more obvious if you can see every thrust—we have reached the more sexually explicit section, as you know . . .

Amplify your facial expressions so that we can always see what is going on in your head.

Scream, sigh, wail, or speak. The video can only capture sight and sound, so many of the senses, such as feeling, smell, and taste are lost. It needs to be apparent how much you like what you are doing.

Don't forget to look at each other. You can also look at the camera because it makes you appear more audacious. Don't look at the corners of the room or the ceiling; that makes you look bored.

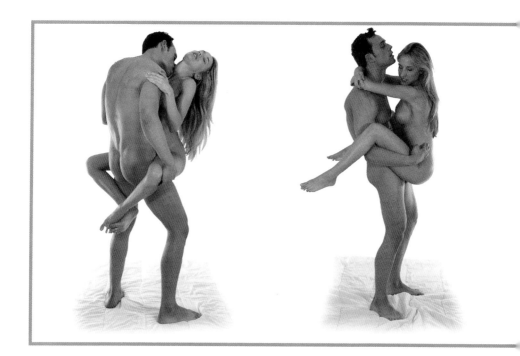

Caress each other so that the sexual tension can be felt. The same goes for the tongue.

A trick for lighting: you can put a translucent screen in between you and the main light. This will soften the contrast between light and shadows, and will also smooth the skin. You can film with many clear mediums in front of the camera lens.

There are many sex positions (and I say this with a wink). A professional mistress from New York realized that her submissives apologized to her for their looks so she decided to incorporate this into gym sessions. Where before there might have been muscle-bound slaves to the gym, thanks to her we now have "slavercise." The theme is obvious, "no pain, no gain."

My boyfriend and I decided to take this idea a step further with erotic videos. My boyfriend can lift me over his head with his arms. Of course, he can't do it too many times in a row, but the effect is very sexy.

Other exercises that we tried included licking my boots every time he lowered himself to the floor in a push-up. There are many exercises that are great for emphasizing arms and the chest, not to mention running and squats. I would also spank him occasionally when he was not exerting himself enough.

I must confess that I felt a few very explosive and powerful moments that day, ordering him to do exercises wearing latex with a whip in hand.

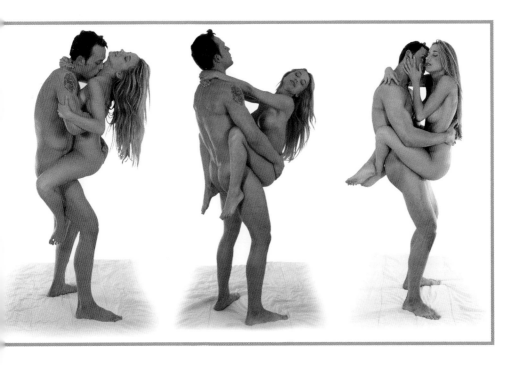

Sex positions II

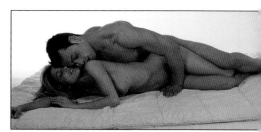

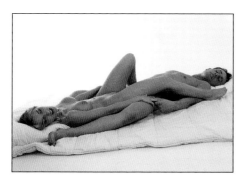

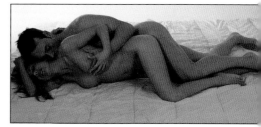

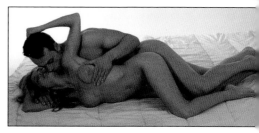

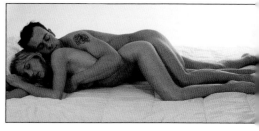

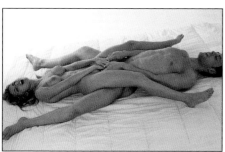

The X

The man lies on his back and the woman gets on him on her knees but backward. Then, she gently slides backward until she is lying on her partner. She is in control.

Gymnastics

He sits on a sofa and she sits on him with her calves supported by his shoulders and hands on his knees to push against.

Sleepy

The woman lies on her side and the man penetrates her from behind. She stretches one leg back and wraps it around his waist. It is very still and is ideal for him to caress her breasts and clitoris, and for her to access his face and neck even though it is temptingly behind her.

The Trapeze

The man sits with his legs spread and she sits on him so that he penetrates her. He can grab her wrists to help keep balance, and she should lean as far back as she can. The man pulls her toward him with his arms while she gives into his strength.

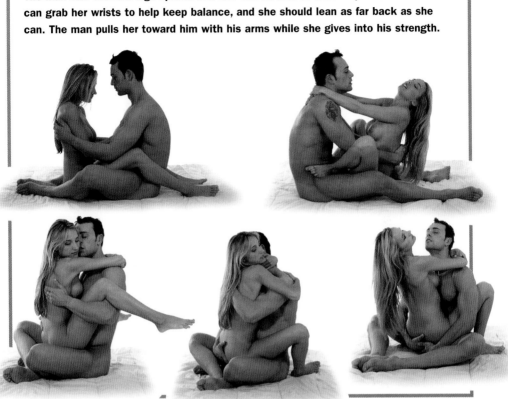

Extreme union

Both partners are lying in bed on their side with their heads at opposite sides joined only at their genitals. She lies on her left side with her left leg bent resting on the bed. He also lies on his left side with his left leg bent, serving as a fulcrum. Each of their other legs will extend along the other's body. For leverage, each partner will grab the other's leg.

Truck

The woman should stand facing the bed or a chair and lean forward until she can support herself with her forearms. The man stands behind the woman and grabs her legs to lift her. The woman wraps her legs around the man's waist and this puts all of the movement toward her hips.

Three Feet

This is also a very showy posture if the partners are of a similar height; penetration occurs with both partners standing. For this to work, she will have to wrap one leg around his body. If you are much different in height, this is not possible, but you can use it as a warm-up, or shrink the height difference by using a footstool.

If the man is strong enough, she can wrap both legs around his waist and wrap her arms around his neck.

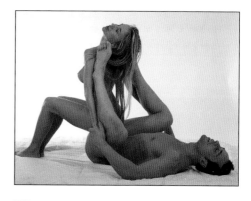

The Amazon

The man lies on his back, with his legs slightly open and bent toward his chest. She slowly squats on his cock. This is a wild position where the woman decides how and how much.

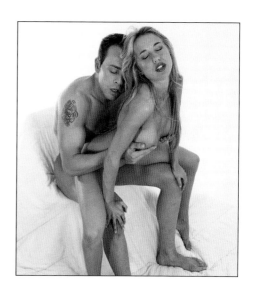

Cowgirl

The woman sits on top of her lover, who is lying down, and puts her knees on both sides of him. When there is penetration, she can lean back and support herself on his knees.

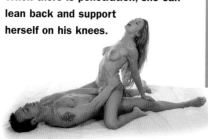

The Chair

The man sits on the bed, chair, or sofa, and the woman sits on top of him.

Reverse cowgirl

He lies down with his legs bent. She straddles him, facing away from him, and leans over his thighs and legs. This position allows you to place the camera so that it gives a tempting shot of her back and ass; from the side, so that you can see the whole position, or from the front so that there is a single shot of her rising and falling on his thighs.

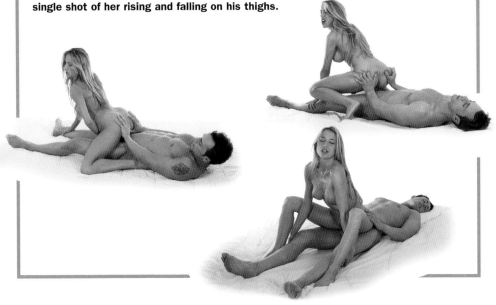

Elephant position

Standing, the woman spreads her legs and lets her hands and chest fall to the ground. The man, also standing, takes her from behind and grabs her by the hips while penetrating her. The movements should be slow, together, and circular.

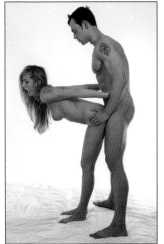
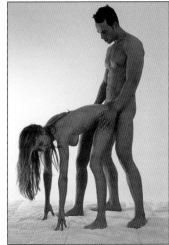

A brief foray into porn genres

The first difference is lighting. *Glossy* movies are ones with bright lighting (even overexposed lighting), are glamorous, have little shadow, and have an unreal and luxurious appearance. This type of lighting has warm tones and gives skin the appearance of peach skin. The light hides wrinkles and cellulite. The effect can be accentuated with bright makeup and body glitter. Of course the actresses are perfectly groomed with perfect bodies.

Gonzo movies are more realistic; they have amateur lighting and show scenarios such as the girl next door having sex with her boyfriend, her husband, or her lover. The lighting might have violent contrast between light and shadow, locations seem more casual and less prepared, and it all has an amateur look—even though it isn't.

In 1989 director John Stagliano revolutionized porn with the movie *The Adventures of Buttman*. It was devoted to investigating the area around his house and filming his "friends" having sex. Currently, Gonzo films represent about fifty percent of the market.

Films of this style can tell the story, starting with the two people meeting, then a conversation that you might find very clever, and finally, in bed. In editing, pick your most brilliant lines and the parts of the movie where you are the most attractive.

There are many sexy possibilities and many different genres of porn. If you do decide to try porn, explore the different genres depending on whether you feel more or less mischievous.

The editors have found it unnecessary to go into too many details in this chapter, leaving it up to you, dear reader, to discover the different genres yourself. The best way is the most basic: watch them.

Terms

You might see terms like "Solo" (masturbation with another person watching), "Facial" (movies where the men shoot semen on the face of the women—(or on the breasts, stomach, ass, back), "Teens" (which has nothing to do with the horrible crimes involving children; where girls—of a legal age—act young or innocent and theoretically have sex for the first time). The *Dirty Debutantes* series is famous for this. There are also videos starring older, more mature adults.

Talk show

One member of the couple will interview the other about their experiences: their first time and how it was, what gets them in the mood, what parts of their body are the most sensitive, their first sexual encounter together, what part of their body do they like the most, a description of their partner's body, memorable experiences that they've had, the strangest place that they have done it, what they would like to do to their lover at that moment . . .

If one of the two partners is jealous, it is best not to ask about former lovers.

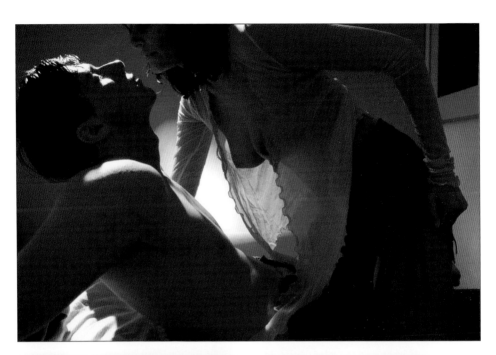

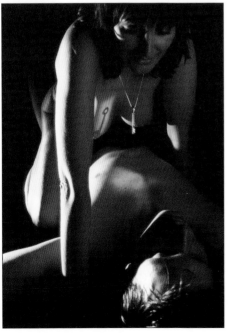

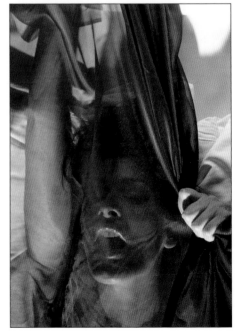

Couples

There is porn made for couples, which tends to be gentler. Classic directors in this genre are Paul Thomas, Michael Ninn, Candida Royale, and Cameron Grant.

Threesomes

These are a porn staple. Maybe it is something that interests you, maybe it isn't. Either way, think about it first. This is something that I insist you talk and think about first because of how emotionally complicated it can get. A piece of advice, do not do it with close friends (for the very naughty, see the following pages). For the sake of the film there is an advantage because it adds a new perspective and each new person will bring a different take to the shoot.

Standard takes in porn

In addition to finding your own shots and points of view, you can borrow some that work very well from porn. They can be very easy to fit to your own preferences. Perhaps you do not like gynecological shots, but you know that there are people who do. If you decide to include them, keep in mind that you will have to illuminate the area with a small light, normally mounted on the camera: the C-light (*cooze light*).

There are three basic parts in a pornographic film: fellatio, cunnilingus, and penetration, all with their own myriad of variations. Let's look at the first.

The classic shot has the man standing and the woman on her knees. First the whole scene or environment is usually shown. Next is the point of view of the man and what he is focusing on. For this, have the woman look at the camera: it is incredibly sexy. In more soft-core films, the back of her head is shown to cover his penis. In the case of the female perspective, there is an extreme close-up of his penis and then a shot of the pleasure on his face.

In typical cunnilingus, the woman is lying in bed (or sitting in a chair), with her legs open, and the man kneeling. There is a close-up of the head and shoulders of the man between her legs.

The male point of view can have a shot of her vagina, or a medium shot of her pussy with his head on it. In the female point of view his head between her legs would be shown from above. She can also straddle his mouth, as he is lying on his back, and you can film it in this position.

In any event, don't forget to get a close-up of her face as she reaches orgasm, even though normally you may not see it, immersing yourself in pleasure and then watching it quietly later.

During penetration do not abuse wide shots and medium shots because they can be boring. Normally, we want to see shots with more detail, so you will have to film more close-ups.

The duration of the movie

A porn movie does not have to be very long. The pacing will depend on your tastes. If one of you likes a more subtle form of arousal, and a slower rhythm, and the other likes it wild and fast, perhaps you can combine the two forms in your movie. You can start slow, for example, with great detail, and then move on to unbridled sex.

A logical time frame, if you do not have a story to tell and you only want to show a sexual encounter, would be five minutes of preparation, about seven minutes of foreplay, including oral sex, and about seven minutes of penetration. Do not overdo the number of sex positions you use or else it will look like an ad for the *Kama Sutra*.

For very, very naughty boys

The content of this chapter is only suitable for the swingers and the very bold. Perhaps the first suggestion is to be ready to follow a number of couples: this is about getting naked, half-naked, or both (meaning you might show your body briefly and then cover up with a coat or a bathrobe or something similar) in public places to add to your videos.

Obviously the most desirable places are famous public monuments. This includes easily recognizable cities such as Venice, New York, Amsterdam, Rome, Paris, or Havana, or spectacular places (like the Grand Canyon, the Amazon Rainforest, towering cliffs, Angel Falls, immeasurable deserts, and more). If you are brave, you can try to film something erotic of both of you. If this is not something you are comfortable with, maybe a hint of a breast with a few buttons undone will be enough, or something more sensual like him standing in front of the camera as she hugs him from the side, and kisses and caresses his neck briefly.

Be careful with the police and the general public, especially in countries where public scandal can be heavily punished. Oh! Another suggestion: don't forget that you can film your own porn in the bathroom of your own house, at least, of course, if you do it in the tub with plenty of foam and candles or other glamorous decorations. But please do not have sex in front of the sink or in other ordinary places.

Don't be blinded by desire when it comes to filming in public places. While having a quickie in the street with your pants down may be very erotic, to film it is simply creepy.

Friends

This is where you have to decide what you really want. It is not worth the pressure or compulsion; the two of you must decide together.

You may be talking with your friends and discover that they have also bought this book and that they also like to experiment with their bodies and their creativity. The next step is to watch movies together and, if you want to involve more couples, establish some kind of prize and try to make your club grow. Throughout the book we have suggested that you keep your videos private, unless you decide otherwise.

If this becomes the case and you decide to share your videos, you will want to make them even better. There are a few more tricks, like shaving a man's pubes to make his penis appear larger and to shoot it from below. To make everything as comfortable as possible, use a water-based lubricant.

Perhaps the next step is to swap partners, at least visually. You can invite your friends to participate in the filming of your videos in a way that is not a serious commitment but to spice up your movies. For example (and a sexy thanks goes to Hollywood, where everything is a lie) add gentle caresses that, when added together; create the illusion that your partner is with another person; maybe hands will be all over the female lead...

If you are really sure that you are ready to be a completely open partner,

then you will surely find people to swap with where everyone takes a turn filming, and a small orgy might even break out (there are so many options: boy-girl, girl-girl, boy-boy, boy-girl-boy).

I have a friend who spent many years in the world of BDSM. She is a submissive who usually participated in fetish parties and is completely uninhibited. So much so that one of her favorite videos is the one where her master "leant" her to the party guests. He blindfolded her and told her to guess who was playing. Each wrong guess led to a punishment.

The master of one of the other party-goers ordered her to perform cunnilingus, and when she was enjoying it the most, my friend's master asked my friend to guess who it was. She was wrong and the other girl had to stop as a punishment.

After many ups and downs, someone took a rope and tied the submissive's legs wide open on a huge bed that was in the middle of the room. At one point, the hands on my friend's body multiplied and she did not know how many people were playing. The girl from before started to perform oral sex again, while two girls stimulated her nipples with their mouths. My friend, overcome

with pleasure, requested permission to have an orgasm, but he denied it.

Everyone left, and without saying a word, he penetrated her. In this moment she screamed his name and, as a reward for being recognized, he gave her permission to cum. Still at the party, they passed the video around so that she could see. It turned her on so much that she pleaded her master for more sex. Despite her master not allowing her to orgasm,

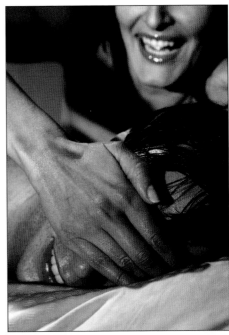

she could not contain herself and came while the two girls were performing oral sex on her on the screen. She had her orgasm, but she still waited that night to be punished for her disobedience. As you can see, it is possible to stage many different situations.

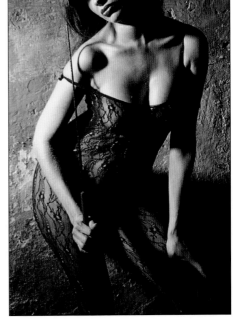

The heart of a stripper

For those who know very little about stripteases, and want to put more emotion in it, there are a number of tricks that professional strippers use to heat up the women at their shows.

The first investment in your striptease should be a stripper pole on which you can dance, slide, swing, strut, lick, and perform all of the other acrobatics that you have been rehearsing. Surely you can find some way to fit it in with your dining room décor.

The soft version of the stripper move is to prepare a cocktail for the woman; preferably both the man and the woman are at the bar counter. This includes (gently) moving the shaker when it is near the man's genitals, shaking the cocktail as if it were his penis, and taking a drink with a straw while it is at the same height, caressing the muscles of his chest from behind and rubbing herself against him, front and back.

The less subdued version of this is where the man becomes a stripper who can please an unlimited number of women at once. You will need spectators then, so film group images, preferably of women applauding, and insert them using Chroma Key in editing. She can sit on a bar stool.

Add similar details to both environments, like flowers on the table (if there are any), candles, or a bottle of champagne.

The girl can play the role of more than one woman by wearing a wig of a different color, glasses, a totally different dress, or maybe even a padded bra.

If you want to throw even more people in, you can invite a few friends to a *Full Monty*–style show and make it a big deal.

What do strippers do after they take off their clothes?

All of the actions below should be carried out shamelessly and in the right mood:

- Walk around the table while the women touch his body.
- Walk around the women showing off and doing pelvic thrusts in front of one of them. He should shake his parts in front of her eyes, nose, or mouth.
- Invite a woman on stage, throw her down, and rub against her, even making it look like you are having sex. Some strippers do this completely naked.
- Tap his penis (which he moves up and down) against a woman's forehead or nose.
- Lay a woman down on stage and pull down her blouse and bra to show off her breasts. Play with a nipple using two fingers.
- Throw a woman down and take off her panties by ripping them. If he is strong enough he can do this with his fingers, if not he can use scissors.
- If he is still wearing shorts, he shows his erect penis from the side and lies on a woman to simulate sex.
- With a woman lying on stage wearing a skirt, open her legs and use a long plastic tongue to simulate cunnilingus.

- The opposite: the stripper is naked over a woman lying down with his penis over her face. He covers the action with black fabric and puts on a look of surprise. Once in a while he removes the cloth to show what she is doing.
- Put a cream on the penis so the women touch it.
- Put whipped cream on the penis so that women will eat it off. If a woman does, put more on.

- He can also put a line of whipped cream on his penis and ask for it to be licked off.
- Ask a woman to masturbate him with her feet to show off her experience.
- All of the previous actions should be accompanied by signs of satisfaction, okay signs, smiles, and a lot of affection.

When it is time to leave the women, a stripper will give them a kiss on the cheek and thank them.

Glossary

Air. Empty space between the top of a person's head and the top of the frame.

"American Night." A shot taken in daylight that is overexposed to simulate nighttime.

Assembly Controller. The device that connects the camera and video player.

Audio Dub. The ability to record or replace sounds on a tape without changing the original picture.

Automatic Gain Control (AGC). Electronic circuit that controls the levels of audio and video during recording.

Backlight. Light behind the subject. If it is the only source of lighting, the protagonist will appear as a silhouette or a shadow. This is usually placed behind the subject to separate the background.

Backlight Equalizer. A command that opens the aperture when working with back lighting. The goal is to properly expose the foreground.

Continuity. Coherence in the details (lighting, costumes, props) between different shots of a sequence.

Countershot. This basically consists of filming a shot of the person speaking and the other person listening. The next shot is the countershot and is the complement to the first. It reinforces the relationship between the two characters and gives them the same emphasis. Counter shots can also involve animals or objects.

Cremer. Lighting fixture that consists of two opaque metal plates that control the amount of light coming from a source. It is mounted on a separate medium and used to prevent background light or other unintentional light from hitting the subject. It can also be used to create shadows on the subject's face for an eerie effect.

Cut In. A shot that picks out a specific part of the action in a bigger shot. It can call attention to an important detail.

Diaphragm (or Aperture). A hole of variable size that determines the amount of light that enters the camera. These are measured in f values.

Diffraction Filter. Filters color effects caused by the diffraction of light rays.

Diffused Light. Direct lighting that is created by diffusing light from a source with a translucent material such as gauze or onionskin paper.

Dolly. Mobile platform that a camera is mounted to on a tripod so that it can move smoothly in tracking shots.

Dubbing. Copying or creating sounds in editing. This can include the sound track, and is mixed onto the final tape.

Flou. A lens that provides a soft and slightly blurred image.

Gels. Gel filters are placed in front of light sources to change the temperature of the lighting or to create certain effects.

Gobo. Lighting fixture. This is a plate with opaque sections used to cast a

shadow on the background of a scene or subject. It can, for example, mimic the shadows created by Venetian blinds or the shade of a tree.

Gray Filter or Neutral Density Filter. Reduces the intensity of light in a scene without affecting the color balance. It reduces the depth of field.

Halo Light. A light source placed behind the subject that forms a bright ring around them and separates them from the background.

Line of Sight. Direction a person is looking on screen.

Photoflood Lamp. A type of photographic light source that emits a beam of 3,400 K, diffused, distributed in a very wide beam. It can smooth the edges of shadows.

Polarized Filter. A light gray filter that reduces reflections from glass and water and reduces glare from bright or reflective surfaces. It can also be used to intensify the colors of clouds or the sky.

Quartz Lamp. Lamp that emits a concentrated light of 3,200 K.

Range. Distance covered by the microphone's sensitivity. Directional microphones will have a greater range.

Ultraviolet Filter. A transparent filter that absorbs ultraviolet light. It is used to sharpen landscapes washed out by the sun.

Video Light. Portable, low-power lighting source. It can be attached to the camera or handheld. It does not give natural light.

Video Mixer. An electronic device that combines video signals from multiple sources. Useful if you would like to do special effects or when recording with multiple cameras.

Wide-Angle Converter. An optical attachment that fits on the camera lens to increase the viewing angle.

Camera Shots

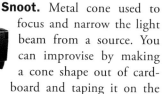

These are terms that they use in the United States:

Ambient Noise. Live sound recorded while in a chosen setting (car noises on the street, water from a stream . . .).

Color Temperature. A measurement of the color of a light source expressed in Kelvin (K).

Crabbing. This is a kind of tracking where the camera moves laterally in an arc around a stationary subject or crossing through the action.

Crab Left or Track Left. Movement to the left.

Crab Right or Track Right. Movement to the right.

Crane Shot. Movement with a crane.

Dolly In or Track In. Forward movement.

Dolly Out or Track Out. Backward movement.

Dutch. The camera is tilted slightly to the side.

Pedestal Up or Crane Up. Upward movement.

Pedestal Down or Crane Down. Downward movement.

Snoot. Metal cone used to focus and narrow the light beam from a source. You can improvise by making a cone shape out of cardboard and taping it on the light. The bright circle emitted is normally placed behind the subject to create a halo effect or as a complementary source of light for close-ups. This is also used to simulate light from a spotlight or flashlight.

Tilt Up. Move slightly upward.

Tilt Down. Move slightly downward.

Video Dub. Substituting the video in editing without changing the original sound.

Vignette. A black matte with an opening in a specific shape. It is mounted on a support in front of the lens and gives the viewer a different way of seeing what is on-screen (for example, as if viewing the scene through a keyhole or framing the scene with a heart).

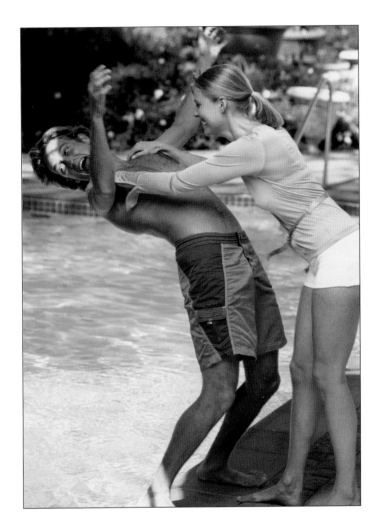